IMAGES
of America
GULFPORT

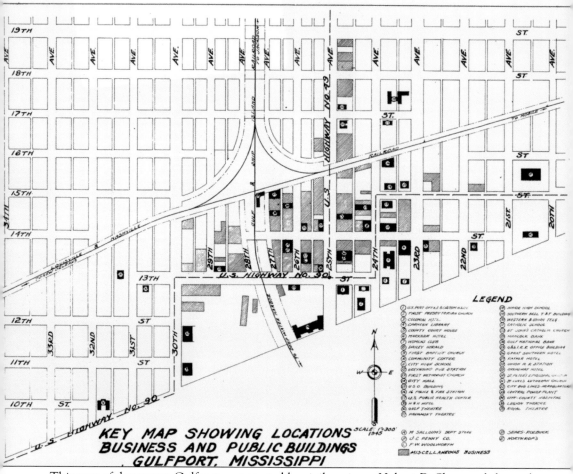

This map of downtown Gulfport was created by civil engineer Hobart D. Shaw and shows the businesses, schools, and public buildings in 1945. (Courtesy of Shaw Design Group.)

ON THE COVER: The Gulf and Ship Island (G&SI) Railroad offices were in the three-story building just north of the Great Southern Hotel. The structure, which also held the post office and telegraph office, opened in March 1903. In this photograph are local officials and employees of the G&SI Railroad. The building—which boasted steam heat, hot and cold water, and indoor toilets—was the fulfillment of a promise Captain Jones made in his speech when the city was established. (Courtesy of Paul Jermyn.)

IMAGES
of America

GULFPORT

Betty Hancock Shaw

ARCADIA
PUBLISHING

Copyright © 2011 by Betty Hancock Shaw
ISBN 978-0-7385-8213-9

Published by Arcadia Publishing
Charleston, South Carolina

Printed in the United States of America

Library of Congress Control Number: 2010941714

For all general information, contact Arcadia Publishing at:
Telephone 843-853-2070
Fax 843-853-0044
E-mail sales@arcadiapublishing.com
For customer service and orders:
Toll-Free 1-888-313-2665

Visit us on the Internet at www.arcadiapublishing.com

To Mayzell and John Hancock, my mama and daddy

CONTENTS

ACKNOWLEDGMENTS

First, I must recognize the accomplishments of my husband, Philip W. Shaw, as an architect. This history does not reflect just the accomplishments of his ancestors. Many of the structures are his design, products of a successful career spanning almost 30 years. Because of his insight and encouragement, there is a book.

Joyce Shaw, my sister-in-law, led the way to Arcadia Publishing. Jim Miller provided not only pictures but also support. Paul Jermyn graciously provided access to his vast collection of historical pictures and postcards. Joe Casey also generously provided images from his collection.

I apologize for any incorrect acknowledgments, for I have done my best to research all the images. I am grateful to everyone who provided help and encouragement. This, of course, includes my children, Daphne and John.

I am extremely grateful to Arcadia Publishing for providing me this opportunity to give others a glimpse of the history of Gulfport, Mississippi.

Unless otherwise noted, all images are courtesy of Shaw Design Group and the Shaw family.

INTRODUCTION

Gulfport, by historical standards, is a young city founded by pioneers of railroading. It is a city with neither the gentility of Mardi Gras balls nor the history of seafood and gambling. Gulfport is a young town with a unique history of prosperity, destruction, and rebuilding.

Gulfport's story begins in the 1840s in the villages of Mississippi City and Handsboro, east of present-day downtown. Location names, such as Mill Road and Brickyard Bayou, belie the true history of the area. An early enterprise was devoted to cutting and selling the timber reserves inland. Along the waterways, there were forests of pines, which were cut at sawmills and floated down to ports to be shipped out as exports. Brick making was another livelihood in the Handsboro area. Mississippi City was south along the gulf, and Handsboro was north of it along the bayous. Because Mississippi City was the center of the county geographically, it was named county seat, and the county courthouse was built there in 1842.

Today, Gulfport is the second largest city in Mississippi. One of the many areas annexed over the years was the large territory north of the city limits that included North Gulfport, Lyman, and Orange Grove (a large area annexed in 1998). There are no incorporated areas to the east or west of the city. Gulfport shares its east boundary with Biloxi and its west with Long Beach. In 1951, Gulfport annexed the 1,200 acres that had been the World War II military installation known as Gulfport Field. Now it is the Gulfport-Biloxi International Airport and the Bayou View subdivision. After annexation, Bayou View quickly populated with homes for returning war veterans and their growing families. However, any town history should start with downtown.

The face of downtown reflected the city's rapid growth, with early businesses, government buildings, cafés, stores, and schools for new residents being established steadily. Capt. William T. Hardy was a railroad man who had founded the town of Hattiesburg, 70 miles north of the Gulf Coast, and planned a rail system running north to Hattiesburg and farther. Capt. Joseph T. Jones, a prosperous Pennsylvania oilman, invested large portions of his vast wealth into the area. He donated land for public buildings, including the courthouse, the library, and a hospital. He gave property for churches and built a beautiful train depot and an office for his Gulf and Ship Island Railroad Company. Captain Jones maintained a residence for himself and his family at the resort hotel he built, the extravagant Great Southern Hotel.

Industry and tourism flourished after 1910 when the railway lines connected Gulfport with Jackson, Mississippi, and points farther north. Another line ran east from New Orleans, Louisiana, and on to Mobile, Alabama. The Union Station Depot (which still stands today) made Gulfport accessible, and the wealthy visited its fine resorts, such as the Great Southern Hotel. Golfing, fishing, hunting, and boating were popular with visitors and locals. The railroad lines played a part in the development of the importing and exporting industries and were followed shortly thereafter by many merchants and professionals. The lumber industry began exporting through the port and on the railroads. Lumber mills sprang up along the banks of rivers and bayous and the north-south railway route. Agriculture boomed as farmers harvested oranges and watermelons

for export. Nuts harvested from tung nut trees were used to produce an oil. The sales of pecans from local orchards became a major part of the economy. Industries included a garment factory, a cotton compress, and the Phillips Milk of Magnesia plant.

As city engineer, Hobart Doane Shaw designed and oversaw the construction of the seawall along the 25 miles of the coastline. Completed in 1926, it was the largest concrete structure in the world at the time. The dedication for the seawall featured a team of synchronized female swimmers and an appearance by Olympic athlete Johnny Weismuller, who later portrayed Tarzan in the movies. The seawall was a means of shoreline protection to secure the land from erosion and increase the desirability of property in the area.

Thousands of military men and women who served their terms of duty at bases in Gulfport are forever linked to the many charms and fascinating history of this city. Gulfport Field, an air base used extensively during World War II, is now the Gulfport-Biloxi International Airport. Gulfport is home to the naval base that is now the location of the Atlantic fleet of the Naval Construction Battalion (Seabees).

The location of Gulfport halfway between the metropolitan cities of Mobile, Alabama, and New Orleans, Louisiana, made reaching the coast convenient for visitors. Gulfport became a major tourist destination. Fishing, boating, and sailing are nearly year-round activities. The bounty of seafood and influx of immigrants through the ports led to an increase in restaurants. Motels geared for family fun dotted the beachfront. Marine Life, an oceanarium, was a longtime attraction for tourists and locals. The early residents enjoyed county fairs and baseball, as well as horse races. Recently, car shows, boat races, and fishing tournaments became annual tourist attractions. The history of golf on the coast goes back many years. Captain Jones's son Albert, a golfing enthusiast, started the Great Southern Golf Club in East Gulfport. There are several championship courses today. Gulfport citizens affectionately refer to northern golfers who vacation here in winter as snowbirds. Deep-sea fishing excursions start from the Bert T. Jones Yacht Basin small-craft harbor. The Ship Island Ferry, owned and operated for decades by the Skremetti family, transports thousands to its shores each season.

Hurricanes play a large part in the history of Gulfport. The storm of 1947, before hurricanes were identified by names, left its mark: trees fell on homes and businesses, boats washed ashore, and sacks of flour that had been awaiting shipment at the port littered the beaches and adjacent yards. Hurricane Betsy of 1965 and others, although significant, were not nearly as destructive as Hurricane Camille in August 1969. Large rolls of paper temporarily stored at the port washed into the residential areas. Of course, none of these storms resulted in the devastation left by Hurricane Katrina in the summer of 2005. This time, almost all the beautiful beachfront homes were gone.

Much of the town's tangible history was gone or had to be demolished. Rebuilding is a colossal task. The people who call Gulfport home and love living here are resilient. The future is bright and the lessons of the past remembered.

One

THE FACE OF

DOWNTOWN GULFPORT

Gulfport, Mississippi, was never a sleepy little village. Selected as the perfect spot for a railroad and connecting port, it came to rival ports in New Orleans, Louisiana, and Mobile, Alabama.

In 1898, Captain Jones spoke of his plans for the area before a group of over 2,000 people. He promised that he would build a bank, mercantile building, train depot, luxury resort hotel, and three-story office building with hot and cold running water. The one stipulation was that the county seat be relocated from Mississippi City to Gulfport. He donated the land where the new courthouse was constructed. Even though the Gulf and Ship Island office was only two stories, Captain Jones made good on his promises. Next, a trolley line connected the coastal towns to transport tourist and residents. The Great Southern Hotel had an electricity-generating facility and an icehouse.

The downtown of Gulfport, Mississippi, thrived. Staring in the early 1900s, hotels near the depot sprung up to accommodate travelers. Coffee shops, restaurants, churches, schools, and movie theaters also began to pop up. A fine city hall, federal building, post office, and newspaper were established. Grocery stores, clothing shops, Chinese laundries, and livery stables provided the needs of people coming to town.

As in other parts of America, suburban development took a toll on the face of downtown. Important businesses—such as Sears, Roebuck, and Co. and J.C. Penney's, once flagships of downtown—moved to Edgewater Mall on the beach in Biloxi in the early 1970s. The train service from New Orleans to Mobile through Gulfport was discontinued. Hurricane Camille in 1969 and subsequent urban renewal efforts resulted in both construction and demolition. Hancock Bank erected an impressive 14-story building, One Hancock Plaza, and the splendid Paramount Theatre was razed.

The face of downtown Gulfport was changed by progress and storms. Now, signs of revitalization are showing in its streets and its buildings.

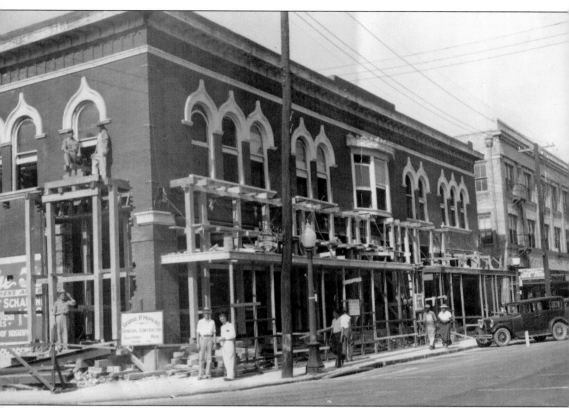

The Salloum building is located on the corner of Fourteenth Street and Twenty-sixth Avenue. This photograph, taken in 1938, shows the process of renovating after a fire. Pictured in the foreground on the corner are contractor George Hopkins (left) and engineer Hobart Shaw. The respective firms of George P. Hopkins, Inc. and Shaw & Woleben, Architects and Engineers, survive today and are owned by their children and grandchildren. The popular M. Salloum's department store was on the first floor. Offices occupied the second floor. A sign painted on one wall advertises men's shoes and "hole proof hosiery." Although several retail stores and offices were located in the Salloum building over the years, it is vacant today.

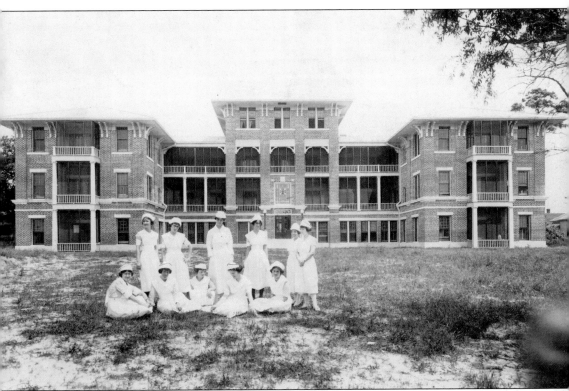

The King's Daughters Hospital was located on West Beach. Pictured above are a group of nurses in white uniforms and starched caps. The hospital, dedicated on May 12, 1922, was designed by Shaw & Woleben, Architects and Engineers. The building was an 80-bed, four-story structure with open porches so that patients could experience gulf breezes and sunshine. Constructed of redbrick walls with grey asbestos-tiled roofing, it was converted into apartments in 1948 but was subsequently torn down in the mid-1990s. The cost to build was approximately $110,000. Captain Jones provided the land.

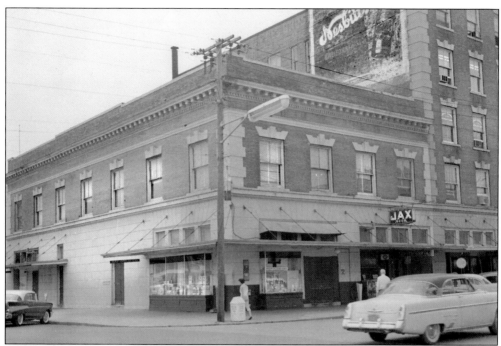

The Salloum family owned this building located on the southeast corner of Twenty-fifth Avenue and Fourteenth Street. Mississippi Power Company had offices on the second floor. Later, the Toggery, a well-known men's clothing store owned and operated by the Salloums, was on the corner. This image, captured in the late 1950s, shows the location of the Stratokos Candy Company under the JAX beer sign.

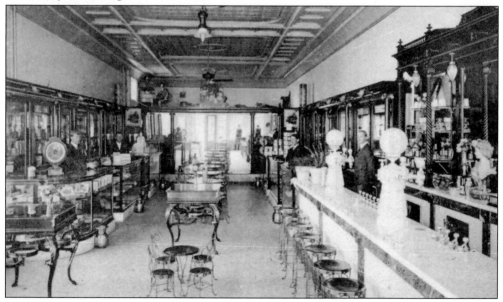

Jones Bros. Drug Company, located on the corner of Fourteenth Street and Twenty-fifth Avenue, had a soda fountain, pharmacy, and retail area. The property was a vacant lot for many years, but Wells Fargo Investments offices are now located in a new building on the site. (Courtesy of Paul Jermyn.)

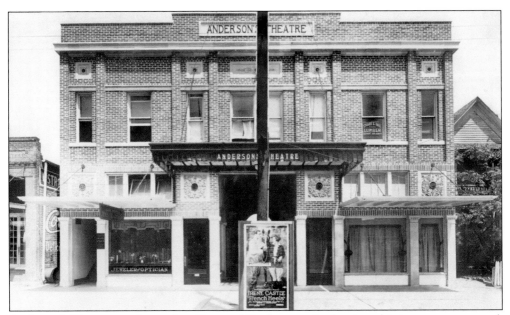

Anderson's Theatre was located on Twenty-fifth Avenue. At the time this image was captured, the marquee announced the 1922 film *French Heels* starring Irene Castle. Designed by Shaw & Woleben, Architects and Engineers, the theater was owned and operated by Vasser Anderson. After Anderson's Theatre closed, Coast Hardware occupied the building for many years. Mississippi Power Company renovated the building and currently has offices there.

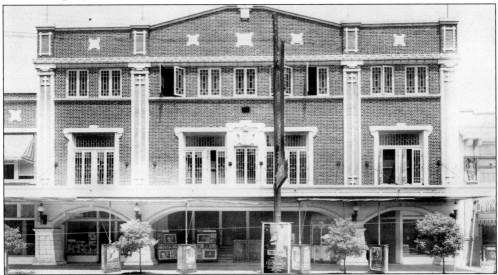

The Paramount Theatre, originally named the Strand, opened on November 1, 1920, to a crowd of 1,500, including mayors from along the coast and guests from New Orleans. The Strand orchestra played for moviegoers who paid 50¢ for the evening performance of *Yes and No* with Buster Keaton. Constructed by Edgar N. Hirsch, the building was designed by Shaw & Woleben, Architects and Engineers. The name changed to Paramount in the 1930s. A renovation in the 1960s reduced the capacity to 700 seats. The last movie there—the James Bond feature, *Moonraker*—screened in 1979. Damaged by Hurricane Frederick later that year, the theater never reopened. Despite efforts by a local group called "Save the Paramount," the owners tore the building down.

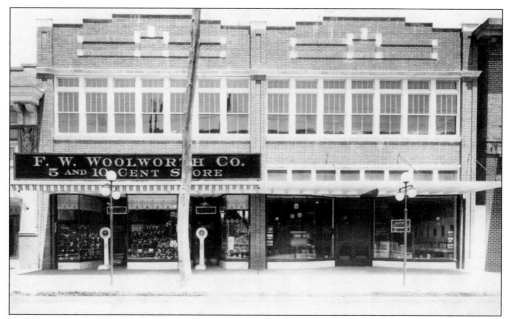

F.W. Woolworth opened on busy Twenty-sixth Avenue in the 1920s. Woolworth's five-and-dime store was a popular location downtown. Its lunch counter catered to businessmen and other locals. There was an ice cream soda fountain here and at McCrory's five-and-dime store on Thirteenth Street. At McCrory's, a customer could pop a balloon and pay the price inside for a banana split. F.W. Woolworth was designed by Shaw & Woleben, Architects and Engineers.

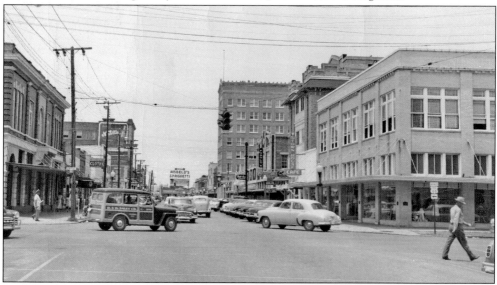

In this 1950s image facing west from the corner of Twenty-fourth Avenue and Fourteenth Street is a neon sign advertising Angelo's restaurant on the beach. Northrop's Department Store is in the right corner of this photograph. Down the street, the large buildings seen are the Masonic Temple and Hancock Bank with a clock mounted on the corner. Hancock Bank opened in the former First National Bank of Gulfport building on August 5, 1932. Downtown Gulfport bustled with businesses like the Town House Café, Fasold's jewelry store, and clothing and shoe stores. There are a couple of signs for the popular JAX beer. Highway 90 ran through downtown at this time.

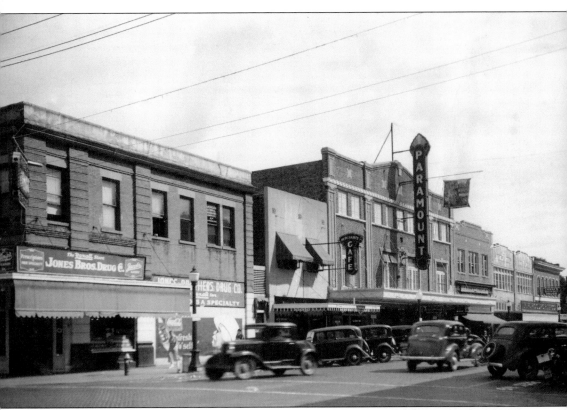

This picture shows the corner of Twenty-sixth Avenue and Fourteenth Street sometime during the 1930s. Jones Bros. Drug Co., Merchants Café, the Paramount Theatre, F.W. Woolworth, and Grant's Drugs operated along Twenty-sixth Avenue. On the far corner is the Splendid Café and Hotel.

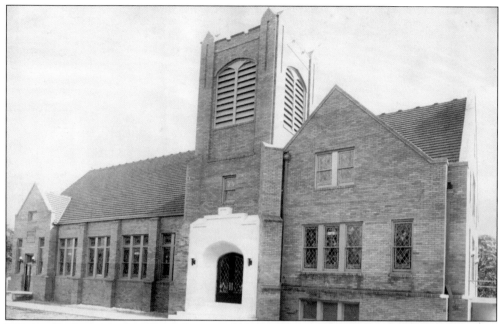

The new Presbyterian church was the second building for this congregation. It was built on land donated by Gulfport's founding father, Capt. Joseph T. Jones, for the customary dollar. This second building was designed by Shaw & Woleben, Architects and Engineers. He was also the clerk of session in 1908 and was probably in attendance when the earlier location received a famous visitor. On December 28, 1913, Pres. Woodrow Wilson and his party arrived in two long black limousines to worship at the original First Presbyterian Church. A third building was dedicated in 1956 but demolished after Hurricane Katrina caused significant damage to the structure.

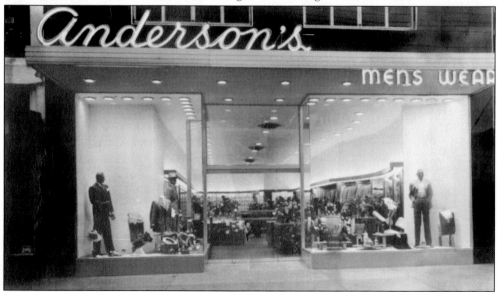

Anderson's Mens Wear closed its doors in 1996 after 83 years. The store was opened in 1914 by Vasser and Tom Anderson. Their nephew "Hully" Anderson operated the store for 51 years. The closing was driven by competition from outlet malls and shopping centers. At the time, Hully was the oldest merchant in downtown. (Courtesy of Joan and Jim Day.)

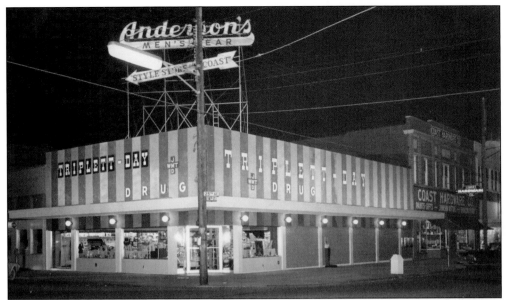

Triplett-Day opened at this location on the corner of Twenty-fifth Avenue and Fourteenth Street. In 1961, a remodeling made the space five times larger. The owners were William M. Triplett and James M. Day. At the two-day grand opening in October, there were sale items and prize giveaways, such as telephone dialers. The store had regular drugstore merchandise on hand, including drugs, medical and surgical supplies, cosmetics, tobacco, and candy. Trained cosmetician Julia Dutcher was in charge of the cosmetics department, as well as the new Helena Rubenstein and Corday lines. (Courtesy of Joan and Jim Day.)

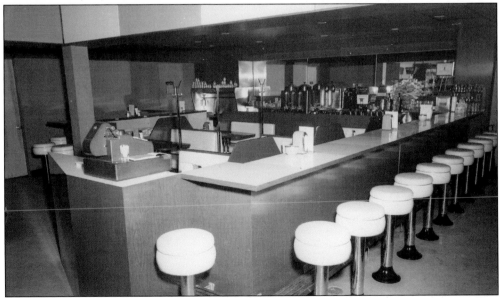

This is a picture of the Triplett-Day lunch counter in 1961. Pharmacist Jim Day and his wife, Joan, a retired nurse, still own and operate the business with their daughter, Poem Love, manager of the gift store department and lunch counter, which is almost the same today as in 1961. The pharmacy department still flourishes with its continued personal service. Loyal breakfast and lunch customers still frequent the counter. (Courtesy of Joan and Jim Day.)

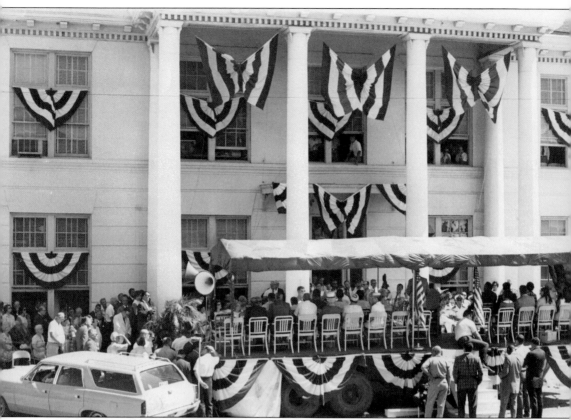

In this photograph taken on July 7, 1969, the windows of the Gulfport City Hall are decorated for the inauguration of Mayor Philip W. Shaw. An olive-green nylon tent shaded the platform set up over the steps leading to the entrance. According to an account in the *Daily Herald* newspaper, approximately 500 people attended. Rev. Famous McElhaney, pastor of Morning Star and Little Rock Baptist Churches, delivered the benediction.

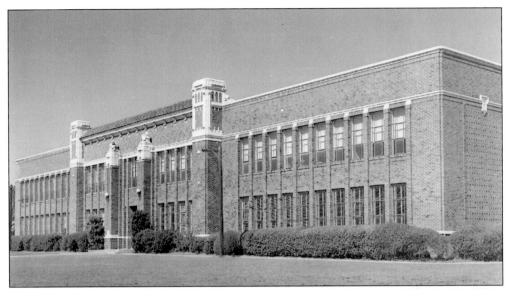

After purchasing land on Fifteenth Street (between Twentieth and Twenty-first Avenues) from Grace Jones Stewart, Gulfport High School was completed in February 1924. The team mascot was a Commodore, and the class annual was the *Log*. This was the only high school until the growing population required a second one, Gulfport East off Courthouse Road. Subsequently, the original Gulfport High School closed because of shifting population trends. The structure became part of the Judge Dan Russell Federal Building. (Courtesy of Glen East, Gulfport Separate School District superintendent.)

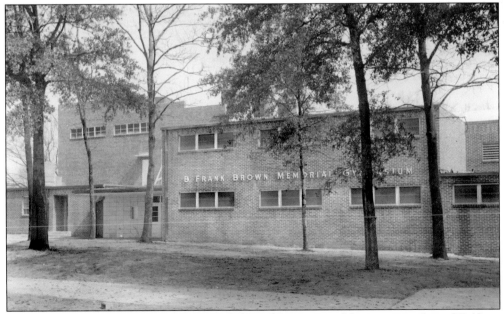

B. Frank Brown Memorial Gymnasium was dedicated in memory of the superintendent of Gulfport schools for 31 years. The new gymnasium, dedicated on January 29, 1955, accommodated gym classes, basketball games, and even graduation ceremonies. The band hall was a part of the complex. The government eventually demolished the gym to provide space for a municipal parking facility. (Courtesy of Glen East, Gulfport Separate School District superintendent.)

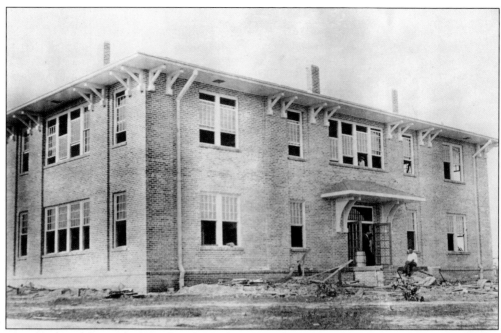

This image is of the original Gulfport High School building under construction in the 1920s. When the new high school was built on Fifteenth Street, this became the junior high school. The site is now the location of the Harrison County Courthouse in Gulfport, between Twenty-fourth and Twenty-third Avenues and Seventeenth and Nineteenth Streets. (Courtesy of Paul Jermyn.)

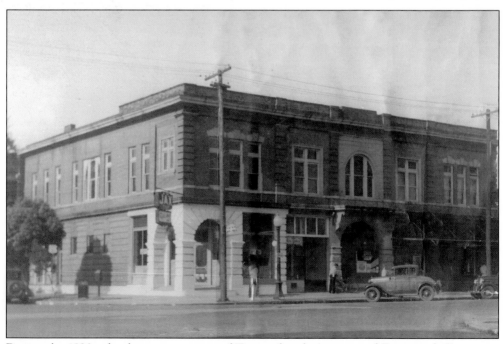

During the 1920s, the downtown corner of Twenty-fourth Avenue and Fourteenth Street was the location of Standard Furniture Company. The building was vacant until it was demolished in the early 2000s. (Courtesy of Paul Jermyn.)

The *Daily Herald* newspaper relocated to the southeast corner of Fourteenth Street and Twenty-third Avenue. The building was designed by Shaw & Woleben, Architects and Engineers. The rest of the block south toward the beach was called Herald Square. (Courtesy of Joe Casey.)

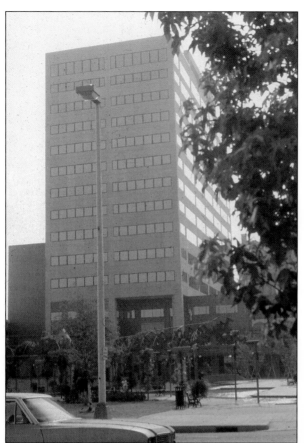

The construction of the Hancock Bank building, located at One Hancock Plaza, was completed in 1981. It is a 14-story building with a connecting municipal parking garage. Several blocks of buildings were demolished in order to erect this business center downtown.

Hancock Bank's water feature was fashioned to replicate the coastline waterfront. This theme carried over into the lobby, with stone representing water and land. The water feature was eventually replaced by a grass lawn. The building, although renovated and changed after Hurricane Katrina, still houses the corporate offices of the locally owned Hancock Bank.

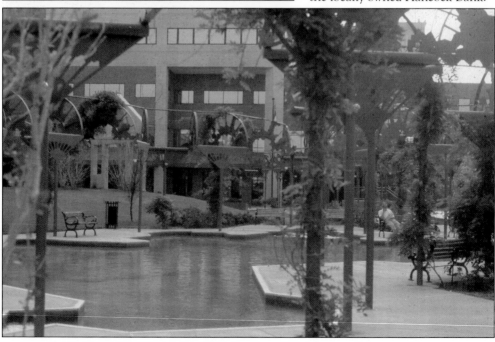

Perez Architects of New Orleans, Louisiana, designed the architectural element seen here near the parking garage of the Hancock Bank. A play area for children was nearby.

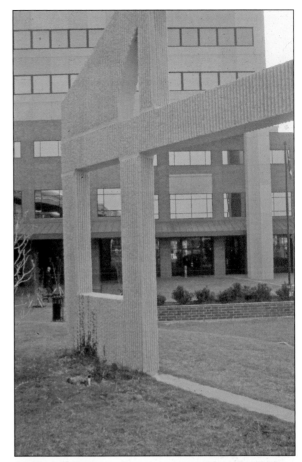

The county jail stood adjacent to the Harrison County Courthouse on Twenty-fourth Avenue. This image was captured to show government support for the prohibition of alcoholic beverages. The officials in the photograph display their bounty. (Courtesy of Paul Jermyn.)

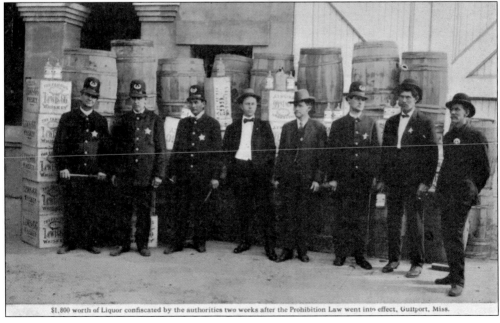

$1,800 worth of Liquor confiscated by the authorities two weeks after the Prohibition Law went into effect, Gulfport, Miss.

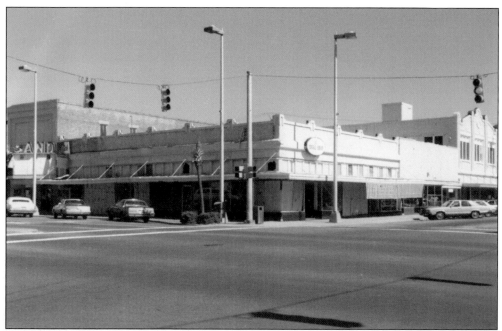

The downtown corner seen here is at the intersection of Twenty-fifth Avenue and Fourteenth Street. The Sand Theatre was one of many movie theaters that closed soon after this picture was taken. A stock brokerage firm and ladies' clothing store were also located here. (Courtesy of Joe Casey.)

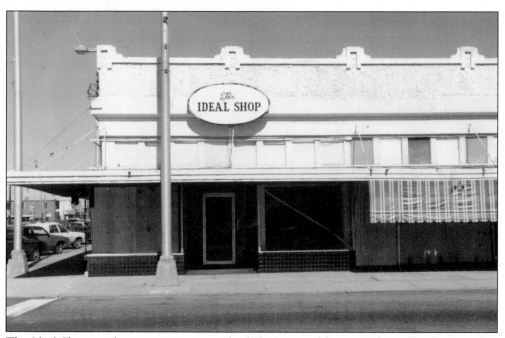

The Ideal Shop on the corner was a popular ladies' apparel business that offered top-quality fashions. The owners relocated to the lobby of the new Hancock Bank across the street behind the old bank building. (Courtesy of Joe Casey.)

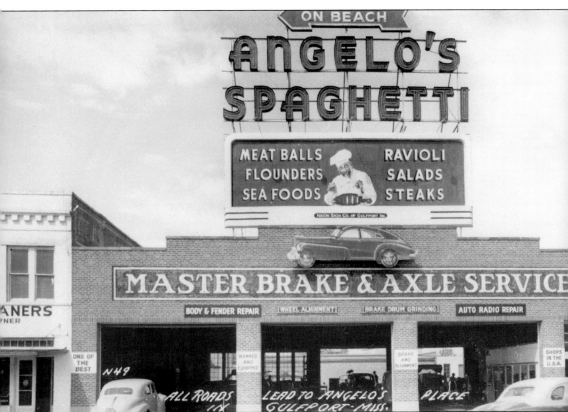

The neon sign high in the air at the west end of Fourteenth Avenue was a well-known directional advertisement for Angelo's Italian restaurant, which was famous for its spaghetti and owned and operated by Angelo Xidis of Greek descent. The restaurant menu also offered seafood dishes, steaks, and salads. It was located just west of downtown on Highway 90. The restaurant survived Hurricane Camille, however, the large oak tree that grew through the roof did not. Vrasel's Fine Dining Restaurant now occupies this location.

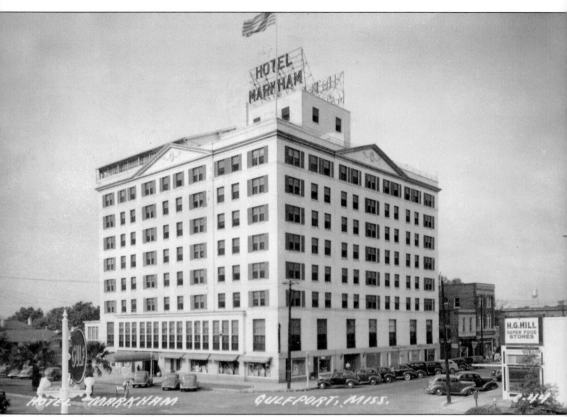

The Markham Hotel cost over $1 million to build and featured a revolving door at its Twenty-third Avenue entrance. Named for Charles H. Markham of the Illinois Central Railroad, a pool on the south side of the hotel was a favorite of children in the summer. There was a coffee shop on the first floor. The lobby opened to a second-floor mezzanine that featured a ballroom, the setting of many parties and wedding receptions. The Markham building was converted into office space in the 1960s. However, it closed after Hurricane Katrina caused extensive damage. (Courtesy of Paul Jermyn.)

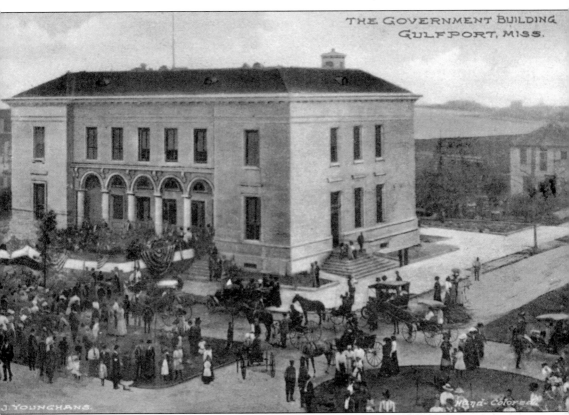

The US Post Office (then known as the Federal Building) opened in 1910. The cost exceeded $100,000. The limestone structure stands today, though most of the postal operations relocated to North Gulfport. The building appears much the same today as it did then. (Courtesy of Paul Jermyn.)

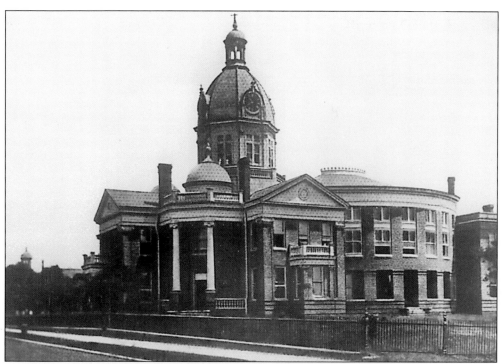

Moving the county seat from Mississippi City to Gulfport precipitated the construction of the Harrison County Courthouse. Completed in 1903, the two-story structure was topped with an ornamental dome. In 1913, a third floor was added. The massive brick and stone building was destroyed by fire in the early 1970s. (Courtesy of Paul Jermyn.)

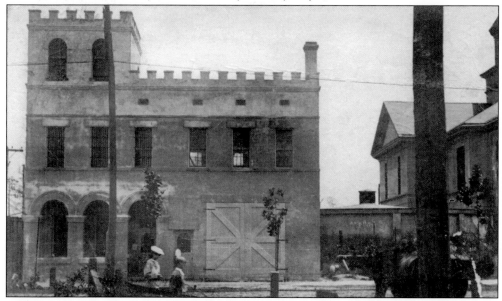

The county jail, built in 1908, was located just north of the Harrison County Courthouse in Gulfport. It was both a jail and fire station. The next jail, built in the early 1950s, was south of the courthouse but relocated as the Harrison County Detention facility on Seaway Road. (Courtesy of Paul Jermyn.)

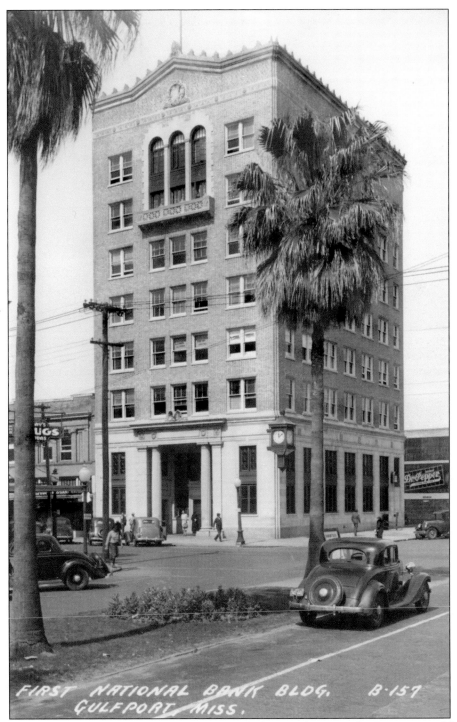

FIRST NATIONAL BANK BLDG. B-157
GULFPORT, MISS.

Located on the corner of Twenty-fifth Avenue and Thirteenth Street, the First National Bank of Gulfport was purchased by the Hancock County Bank during the Depression. The bank is still standing. Today, Hancock Bank is a major regional institution with locations in Mississippi, Louisiana, Alabama, and Florida. (Courtesy of Paul Jermyn.)

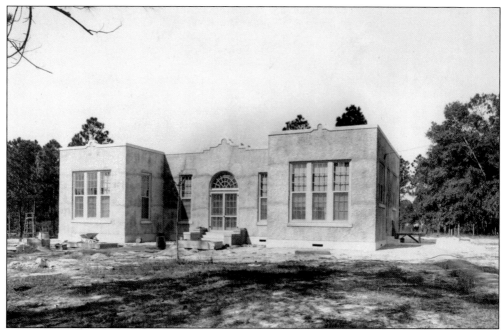

This image is from a portfolio of projects by Shaw & Woleben, Architects and Engineers, in the 1920s. Probably Northeast Ward Elementary School on Twenty-second Avenue north of Pass Road, it was an excellent example of the architectural details used during that time frame.

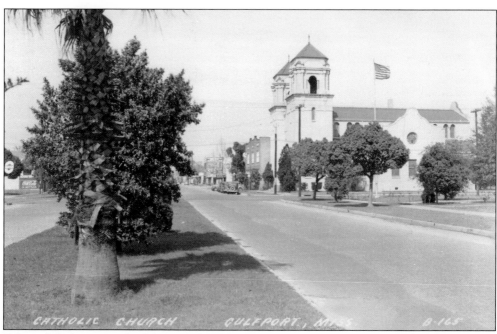

Taken while facing north of the west-to-east railroad tracks, this picture of Twenty-fifth Avenue was probably from the late 1920s or early 1930s. Palm trees and oleander shrubs line the boulevard median of what is now Highway 49. On the right is the St. John the Evangelist Catholic Church built in the 1920s but founded as St. Francis de Sales Academy in 1901. (Courtesy of Paul Jermyn.)

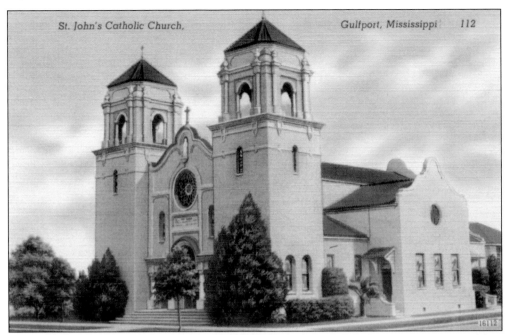

Started in 1922, St. John the Evangelist Catholic Church was completed in 1924. Shaw & Woleben designed the Spanish Colonial–style church. Located on the northeast corner of Twenty-fifth Avenue (now Highway 49) and Seventeenth Street, the building was razed after enduring Hurricane Camille and then replaced by a modern structure. This is a rendering provided by the architectural firm.

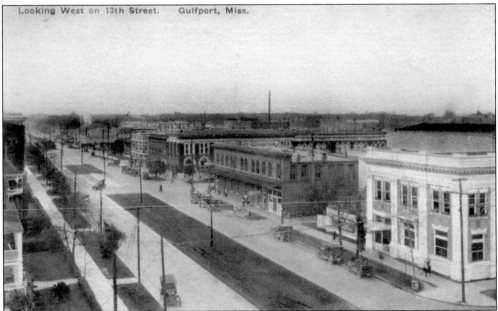

Looking West on 13th Street. Gulfport, Miss.

The date of this image is unknown, but it was captured facing northwest at the corner of Twenty-fifth Avenue and Thirteenth Street. The Kremer building in the right foreground has only two stories, but a third was added in the 1920s. An insurance company was the original occupant.

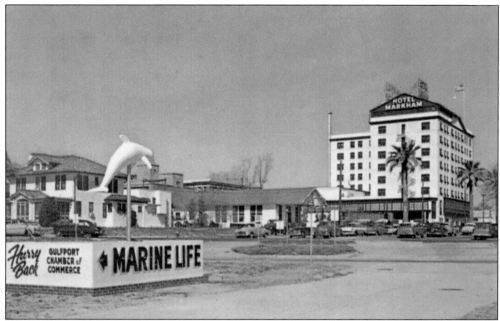

Marine Life, advertised as the "Wonders of the Sea," was a major tourist attraction. From the beginning, Marine Life featured trained porpoises and seals. Visitors watched through glass as divers swam among the fish and sea turtles in large tanks. Located on the beach near the small-craft harbor, Marine Life drew many tourists. Included in the price of admission was a trip of the Gulfport harbor on a tour train. (Courtesy of Paul Jermyn.)

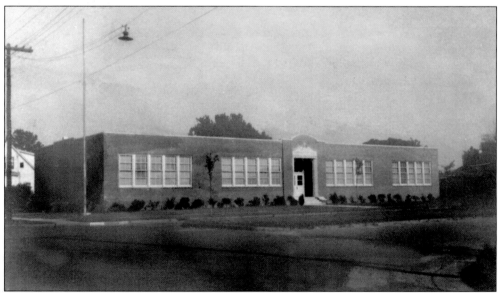

St. John's Elementary School is located on the southeast corner of Twenty-fifth Avenue and Nineteenth Street. Across from St. John the Evangelist Church, this elementary school has served local Catholic children since the 1950s. The building, although expanded, still operates on this site and has sustained no major damage from hurricanes. However, the school is closing due to decreasing enrollment. (Courtesy of Paul Jermyn.)

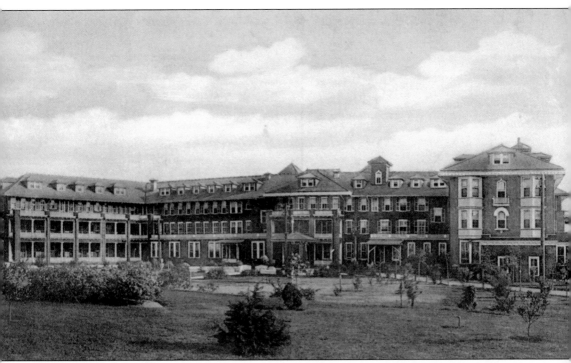

The Great Southern Hotel seen in this postcard was built by Capt. Joseph T. Jones and opened in July 1903. The resort facility advertised a temperate climate just right for fishing, hunting, and sailing. The fact that the location was accessible by rail was a great advantage. The location offered gulf breezes and fine views. Captain Jones and his family lived in a suite in the beautiful resort. (Courtesy of Paul Jermyn.)

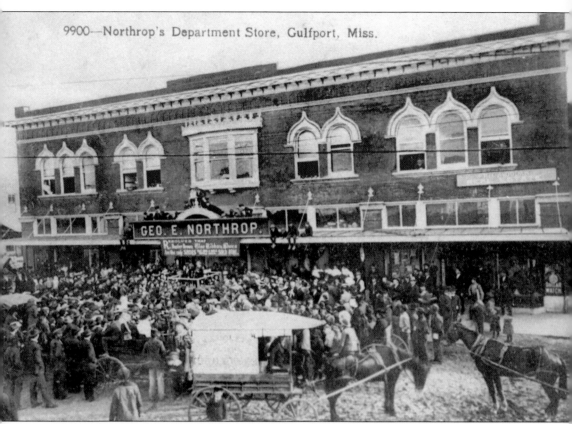

9900—Northrop's Department Store, Gulfport, Miss.

GEO. E. NORTHROP.

When the original Northrop's Department Store held its grand opening, Buster Brown and his dog, Tige, were among the guests. The Buster Brown Shoe Company sent the child actor and his dog around the country to make appearances at store openings, where they would perform tricks, tell jokes, and sell shoes. Northrop's Department Store moved downtown to a building at the northwest corner of Twenty-fourth Avenue and Fourteenth Street in the 1920s. (Courtesy of Paul Jermyn.)

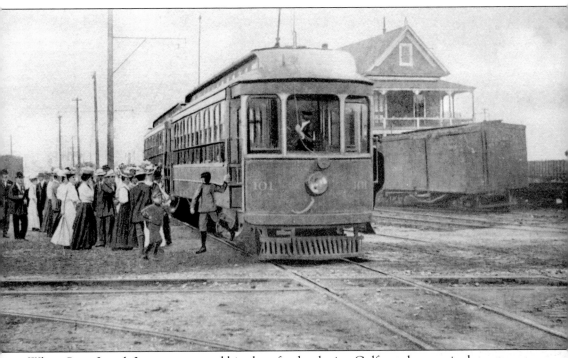

When Capt. Joseph Jones announced his plans for developing Gulfport, he promised streetcars along the beach from Pass Christian to Biloxi, and he quickly made good on that promise. However, the trolleys would obstruct the view of the water for the residents of Pass Christian. Many of the houses there were second homes for wealthy New Orleanians who would travel from Louisiana by train. Concessions were made to the residents by placing the trolley lines north of their mansions. Only in Pass Christian were the trolleys behind the homes and not along the beachfront. (Courtesy of Paul Jermyn.)

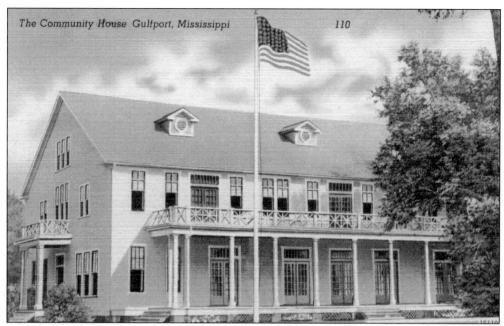

The community center was a boon to downtown. Like many other civic projects, Joseph T. Jones paid for construction of the building. (Courtesy of Paul Jermyn.)

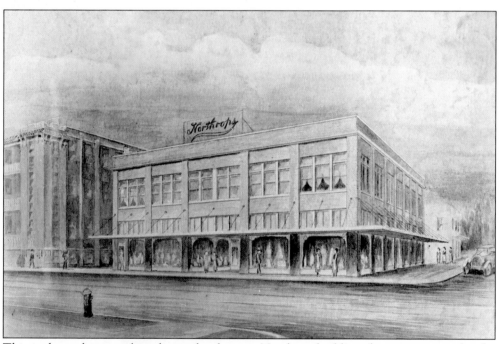

This is the architectural rendering for the new Northrop building that was proposed to be erected at the corner of Fourteenth Street and Twenty-fourth Avenue in the 1920s. Northrop's was a popular department store. During the 1960s, a pair of shoes, or even Sans Souci lingerie, from Northrop's was a must-have for teenage girls. The building was demolished a few years after Hurricane Katrina. Today, a parking lot sits in its place.

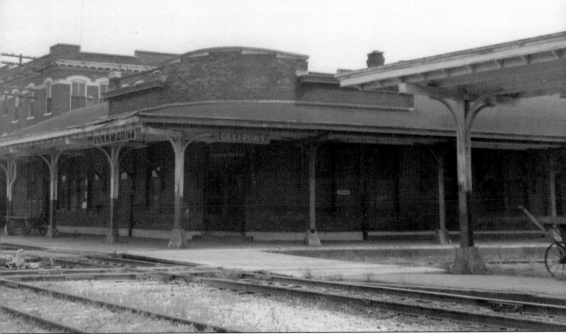

The railroad depot was built by Captain Jones for the Gulf and Ship Island Railroad around 1900. The date of this image is unknown. It is taken from north of the railroad tracks. In the 1970s, the building was renovated under the direction of Shaw-Walker, Architects, and has since housed restaurants and a museum for Gulfport. Hurricane Katrina caused extensive damage to the structure.

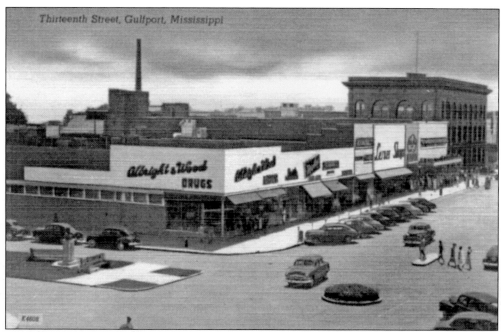

The image above is from the 1950s. After the Great Southern Hotel was torn down in the late 1940s, a development company built a shopping plaza for nationally known tenants. In addition to the drugstore, there was a Lerner's of New York clothing store and a jewelry store. Still visible is the power-generating building in the far left, which was erected by Captain Jones.

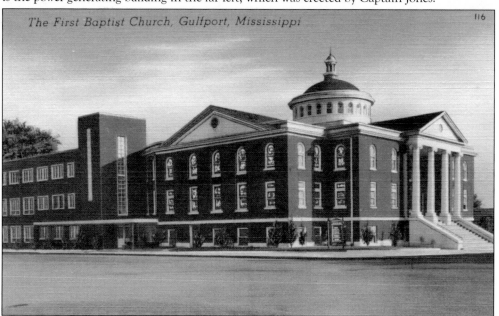

The First Baptist Church, Gulfport, Mississippi

116

The First Baptist Church is located on the southeast corner of the intersection of Fifteenth Street and Twenty-fourth Avenue in original downtown Gulfport. The imposing structure, with its beautiful stained glass domed sanctuary, was constructed in the 1910s across from city hall. Having survived many hurricanes, it is one of the oldest houses of worship left on the Mississippi Gulf Coast.

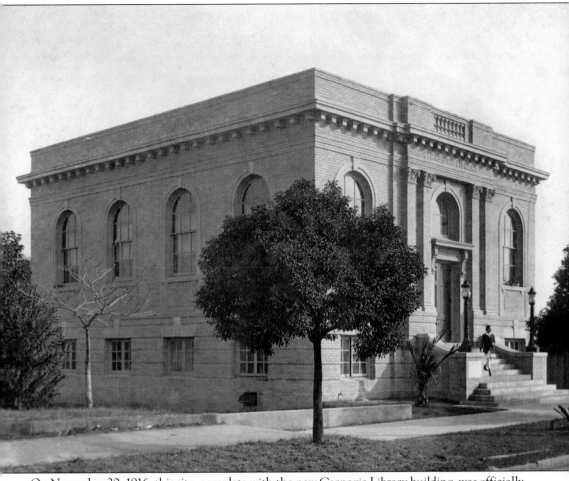

On November 20, 1916, this site, complete with the new Carnegie Library building, was officially turned over to the city. The location adjacent to the new county courthouse on Twenty-fourth Avenue was an ideal place for the library. Gulfport's library was one of many built around the country through the philanthropy of Andrew Carnegie. A documented time capsule from 1916 was never found in the building. Now the City of Gulfport owns the structure it restored. It is the only building left on the east block of Twenty-fourth Avenue between Fourteenth Street and the beach road. (Courtesy of Paul Jermyn.)

The Commercial Bank and Trust Company building, erected in 1904, was designed by Shaw & Woleben, Architects and Engineers. Located on Twenty-sixth Avenue between Thirteenth and Fourteenth Streets, the bank failed during the Great Depression of the 1930s. The Commodore Café was one of the businesses that later occupied the building. (Courtesy of Paul Jermyn.)

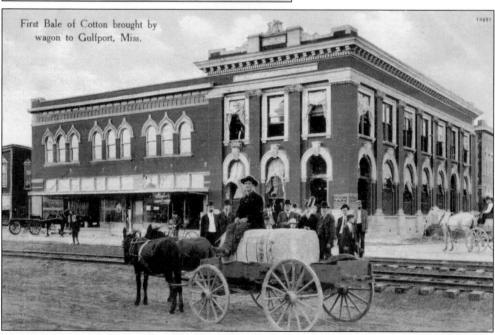

First Bale of Cotton brought by wagon to Gulfport, Miss.

Pictured is one of the first bales of cotton destined to be exported through the Port of Gulfport. Exporting was the major impetus for success of the Port of Gulfport. Capt. Joseph T. Jones's plans for Gulfport were successful when local products began to be shipped out of the new port. (Courtesy of Paul Jermyn.)

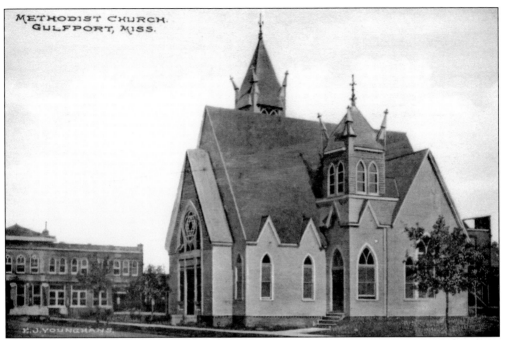

This is an image of the First Methodist Church in downtown. When destroyed by fire, the building was replaced with a brick structure. The establishment of places of worship reflected the growth of the city as a family community in the early part of the 20th century. (Courtesy of Paul Jermyn.)

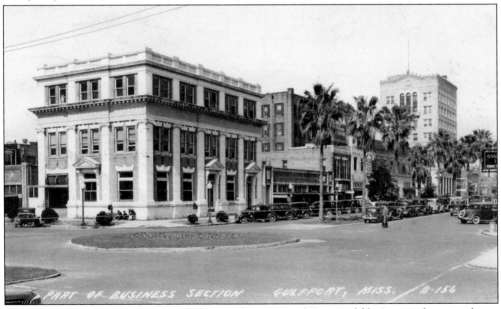

This 1930s view from the corner of Thirteenth Street and Twenty-fifth Avenue faces northeast on what is now Highway 49. The large palm trees on the boulevard have been replanted, and the entire block of buildings remains intact today. One of the few families residing downtown live on the second floor of a two-story building in the middle of the block; here, they weathered out Hurricane Katrina. (Courtesy of Paul Jermyn.)

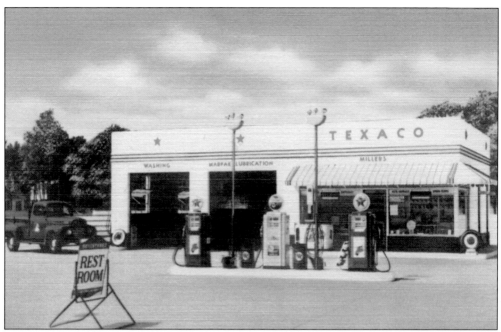

Miller's Texaco was a full-service filling station located on Fourteenth Street. The owners would repair, wash, and service their customers' vehicles. Notice the advertisement for restrooms. (Courtesy of Paul Jermyn.)

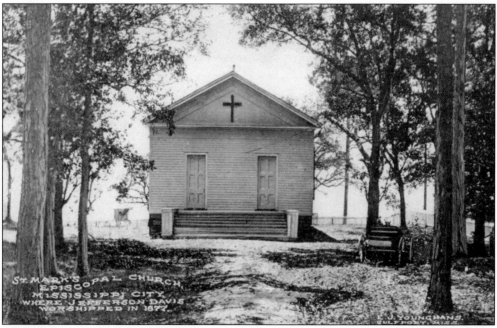

St. Mark's Episcopal Church was modest in its first location along the beach in Mississippi City. The church was rebuilt after Hurricane Camille in 1969. Hurricane Katrina forced members to move to a location on Cowan Road. Jefferson Davis, president of the Confederate States of America during the War between the States, sometimes worshipped here during his retirement. (Courtesy of Paul Jermyn.)

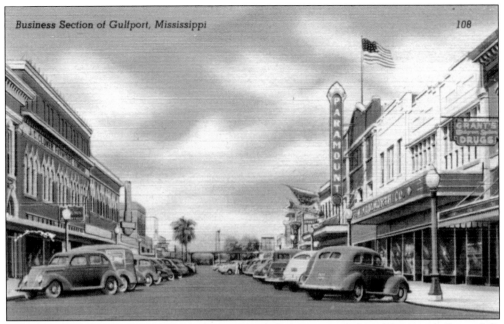

This color postcard shows Twenty-sixth Avenue while facing north from Thirteenth Street. J.C. Clower Furniture Company is on the left. On the right is the Paramount Theatre (formerly the Strand). Grant's drugstore in the foreground is a Walgreen's system store. Grant's had a popular lunch counter that attracted downtown shoppers and business people. (Courtesy of Paul Jermyn.)

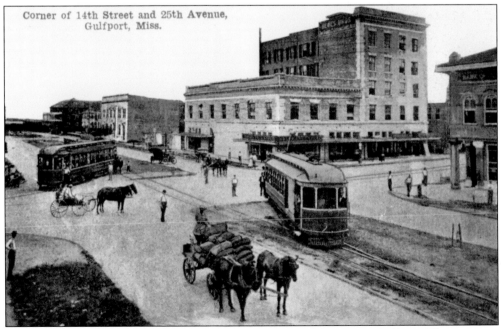

This is an early-20th-century image facing southwest toward downtown Gulfport. The streetcars are competing with the horse-drawn carriages in the streets. This is the corner of Twenty-fourth Avenue and Thirteenth Street. Hewes Brothers (tall building at center right) was a popular mercantile store. (Courtesy of Paul Jermyn.)

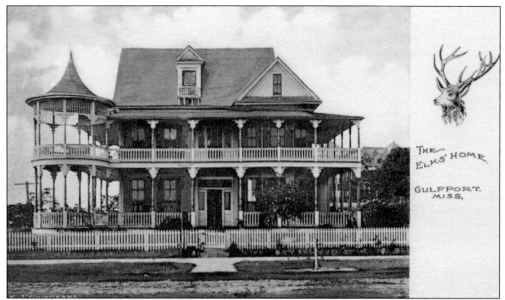

This ornate building was the original home to the fraternal organization of the Elks. Male brotherhoods, such as the Masons and the Pythians, flourished in downtown Gulfport. This building was destroyed by fire, and organization relocated to a new structure on East Beach Boulevard. That building, in turn, was heavily damaged by Hurricane Camille in 1969. The new structure was totally devastated by Hurricane Katrina in 2005. The Elks are now temporarily located in the Orange Grove area. (Courtesy of Paul Jermyn.)

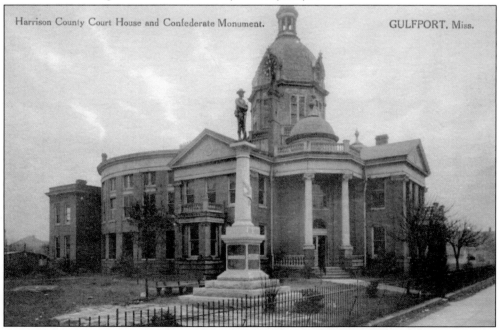

The Harrison County Courthouse on Twenty-fourth Avenue replaced the old courthouse in Mississippi City. At Capt. Joseph Jones's urging, the new county seat was Gulfport. The monument to the Confederate soldier is typical of statues on courthouse grounds in the South. When the courthouse was rebuilt in its new location, the statue followed. (Courtesy of Paul Jermyn.)

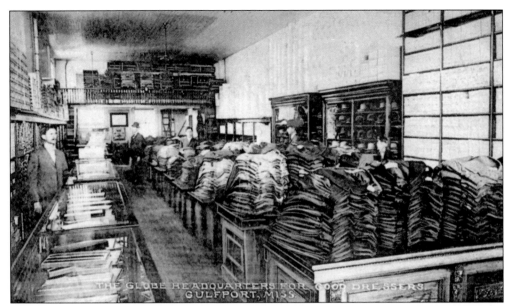

Another popular store in downtown Gulfport was the Globe. In the 1910s, the counters were stacked high with clothing to meet the needs of the growing population. Retail stores had no stockrooms. The cases lining the walls display men's hats for sale. (Courtesy of Paul Jermyn.)

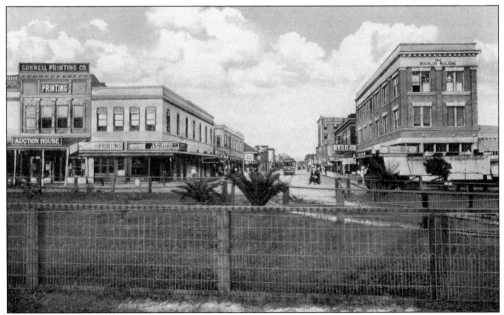

The trolleys ran down the middle of the streets, providing transportation to many of the businesses downtown. This picture faces south from the railroad on Twenty-seventh Avenue. The Bouslog family was influential in the development of the port and railroad. The printing company and auction house are new businesses. (Courtesy of Paul Jermyn.)

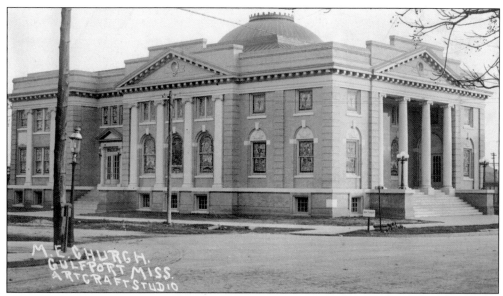

The Methodist Episcopal Church is located on the corner of Twenty-fourth Avenue and Fourteenth Street across from the Gulfport City Hall. The glass dome is painted with religious murals. Notice the gas streetlight on the left in the foreground. (Courtesy of Paul Jermyn.)

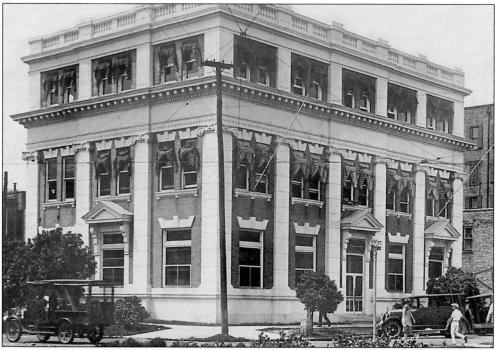

The Kremer building was originally erected with only two stories. However, in this image from the 1920s, a third story had been added. Originally the office of an insurance company, it is located on the northwest corner of Twenty-fifth Avenue (also known as Highway 49) and Thirteenth Street. This image shows a Model T Ford "Depot Hack" in the bottom left corner. Depot hacks were vehicles primarily used to transport people and their luggage to and from train stations. (Courtesy of Paul Jermyn.)

Two

GULFPORT'S HISTORY

Gulfport's history lies in the story of its port.

The founding fathers of Gulfport knew the importance of location. Being situated halfway between the port cities of Mobile, Alabama, and New Orleans, Louisiana, the Mississippi Gulf Coast provided an ideal location for an additional port. The barrier island, Ship Island, provided a natural deepwater channel leading inland. Sailing vessels could dock at the island and send smaller ships in to transport goods back and forth.

Capt. Joseph T. Jones, a wealthy Pennsylvania oilman, helped create an extension of the deepwater channel to the port to provide enough depth for oceangoing vessels to have access directly to the harbor to unload cargo.

In 1900, the population of Gulfport was approximately 1,060. In 1906, that number had increased to 14,000. Goods moved in and out of the port and by railway. The Gulf and Ship Island Railroad had literally made way for the lumber industry, as lumberyards and sawmills sprung up along the railway route running north from Gulfport harbor. Other exports would abound, including cotton, oranges, and watermelon.

Over the years, the exports and imports have changed. Exportation of chickens to Russia was prevalent in the 1990s. Banana importation started in the 1950s and continues today as a viable and profitable trade.

The Port of Gulfport is a crucial container port today.

Capt. Joseph T. Jones was president of the Gulf and Ship Island Railroad. An affluent Pennsylvania oil tycoon, Jones invested much of his vast wealth to establish the City of Gulfport.

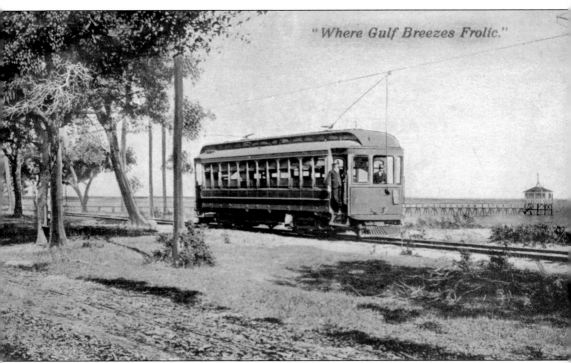

The streetcars, referred to as the interurban railway service, also ran along the beach, connecting the villages of Biloxi, Beauvoir, Mississippi City, Gulfport, Soria, Long Beach, and Pass Christian from east to west. This picture shows the pine trees and vegetation near the shore. Out over the water is one of the many piers that dotted the shoreline. Residents' land stretched toward the water, and the private piers ended with pavilions for recreation. (Courtesy of Paul Jermyn.)

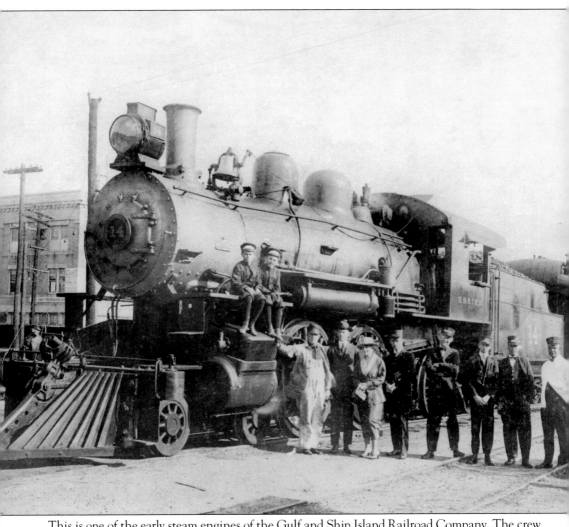

This is one of the early steam engines of the Gulf and Ship Island Railroad Company. The crew and passengers, as well as a port and two young boys dressed in railroad uniform, appear to be posing in the photograph above. Steam engine No. 14 was produced by the American Locomotive Company. Thirty-two passenger trains ran daily into Union Depot. (Courtesy of Paul Jermyn.)

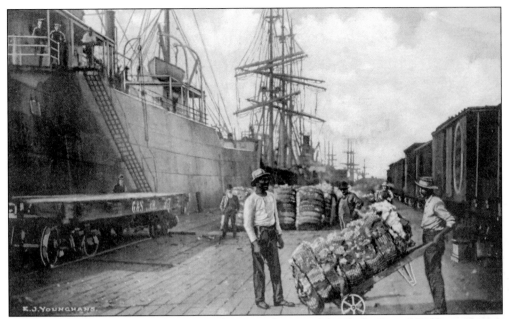

A major boon to the area was the eventual export of cotton through the Port of Gulfport. Cotton bales were transported by the G&SI Railroad and loaded on the waiting steam liners bound for Europe. (Courtesy of Paul Jermyn.)

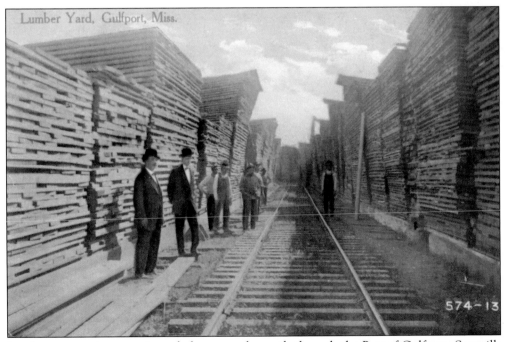

Lumber exportation experienced phenomenal growth through the Port of Gulfport. Sawmills along the rail lines in the nearby forests cut the pines and sent them to lumberyards alongside the railroad tracks. (Courtesy of Paul Jermyn.)

"O turn thy rudder hitherward awhile,
Here may thy stormbeat vessel safely ride."

In the early 1900s, cargo ships anchored outside the harbor would await their turn. In 1908, imported pyrites of iron arrived at the port consigned to Nashville, Hattiesburg, and Meridian.

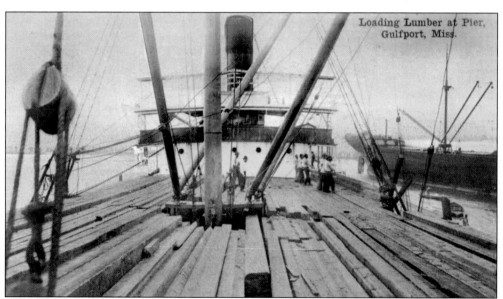

Loading Lumber at Pier, Gulfport, Miss.

Capt. Joseph T. Jones paid for the cost of dredging the channel leading to the Port of Gulfport to 24 feet deep and 300 feet wide. The deepwater channel completed in 1902 allowed oceangoing ships to enter the port to load the vast amounts of timber exported. In 1907, Gulfport was the leading exporter of yellow pine lumber in the world. (Courtesy of Paul Jermyn.)

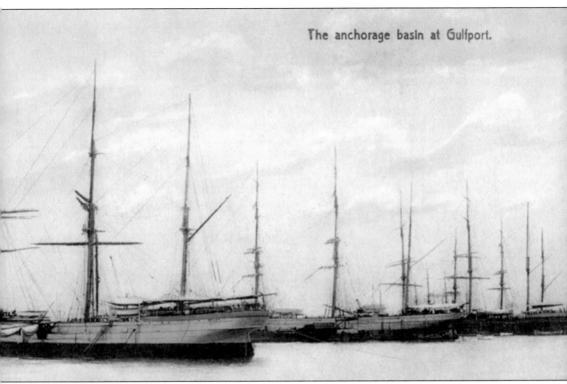

One vessel with 9,000 bales of cotton and tons of cottonseed oil cakes left for Liverpool, England. (Courtesy of Paul Jermyn.)

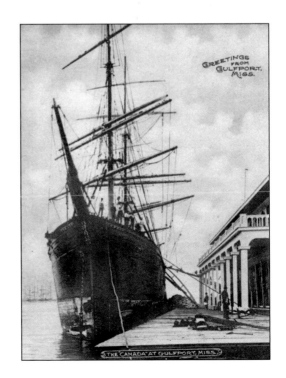

The ship *Canara* carried 2.7 million board feet of lumber from Gulfport. It took 225 railway cars to bring it to the ship. The basin and channel were deepened to 24 feet. (Courtesy of Paul Jermyn.)

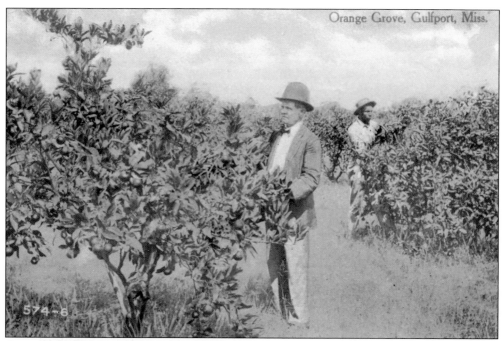

Oranges and satsumas were a winter crop in Gulfport, and the suburban area located north of the early city limits is known as Orange Grove. Homes and major shopping centers are located along this area that contains the east-west interstate highway. (Courtesy of Paul Jermyn.)

Since the 1950s, the Port of Gulfport has been a major center for the importation of bananas into the United States from Central and South America. Today, Dole and Chiquita trucks line up in long rows to load the fruit for distribution throughout the country. (Courtesy of Paul Jermyn.)

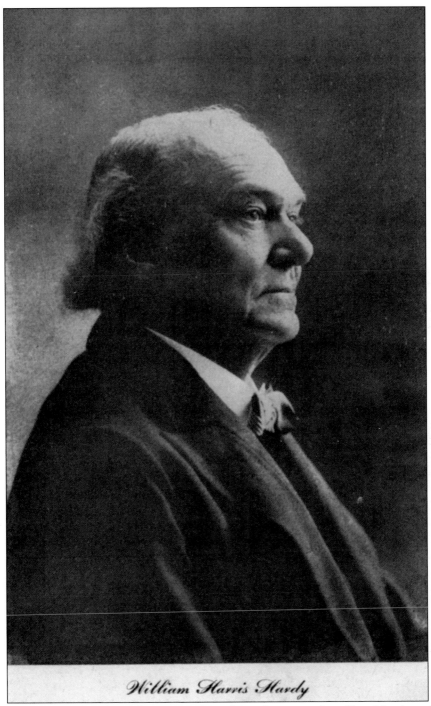

William Harris Hardy

Captain Hardy first thought of the concept for a channel running from Ship Island to a harbor in Gulfport. Hardy was also the founder of Hattiesburg, Mississippi. He established the railroad line, which ran north from Gulfport. (Courtesy of *Mississippi Volume IV Supplement*. By Dunbar Rowland, 1907. Reprinted 1976. From the Archives of Mississippi Gulf Coast Community College, Dr. Charles Sullivan, curator.)

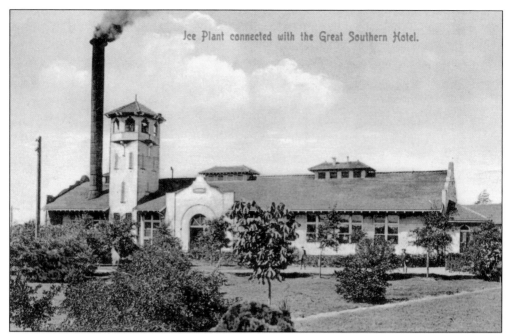

Capt. Joseph Jones built an icehouse and an electric powerhouse on the grounds of his Great Southern Hotel. The electricity was provided for the downtown businesses, which made good on another promise he had spoken of to the citizens of Gulfport. Electricity and ice were valued commodities in the early 20th century. (Courtesy of Paul Jermyn.)

The original county courthouse located in Mississippi City was a wooden structure built in the 1830s that burned in the 1920s. After the county seat was relocated to Gulfport, the chancery clerk's office was on the first floor and the jail was on the second floor in a brick facility for a time. This picture was taken before renovation during the administration of Gulfport mayor Leroy Urie in 1987. The historical renovation and an addition for the tourism commission was undertaken by the firm of Shaw-Walker, Architects. After Hurricane Katrina destroyed the historical structure, the city demolished the remaining addition and built a replica.

Three

BUILDING THE SEAWALL

Beach erosion became a concern for many people living on the Mississippi Gulf Coast. Although living along the shoreline had always been desirable, the fact that storms and other natural occurrences were causing erosion became a real issue.

For several years, a shoreline protection commission had been working to establish some kind of beach stability. Finally, in the early 1920s, the Harrison County board of supervisors approved a proposal to build a seawall to protect the beachfront.

City engineer Hobart Doane Shaw, who spent a great deal of time researching beach protection alternatives around the world, was hired to design the seawall. Paid for by taxpayers voting in a bond issue, some were reticent in their support. However, when the vote came for the second phase, support was overwhelming.

When completed in 1926, it was the largest concrete structure in the world until Hoover Dam was built in 1938. At a total cost of $3.5 million to the taxpayers of Harrison County, the passage of the shoreline protection law and construction of the seawall are credited with raising property values and sealing the future of Gulfport as a tourist and retirement destination.

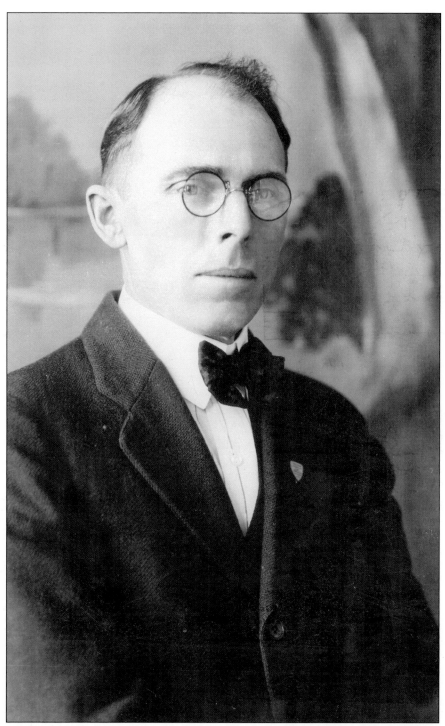

Hobart Doane Shaw, a native of Carroll County, arrived in Gulfport by train. Shaw served as city engineer in Gulfport for 38 years. Shaw's engineering and architectural firm operates today as Shaw Design Group. He designed the seawall, considered by many to be the greatest engineering feat until completion of the Hoover Dam.

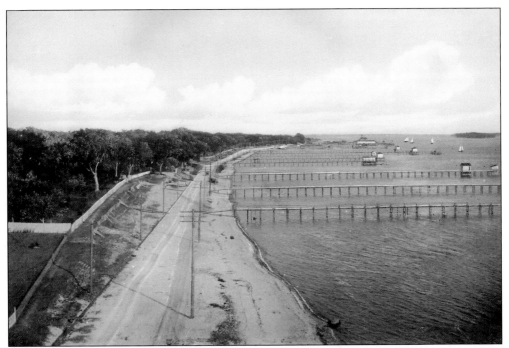

This is a unique aerial photograph taken before the seawall was erected in Gulfport. Many owners of beachfront property built long piers off of which they could fish and swim. Notice the erosion of the land. A beach road is almost nonexistent.

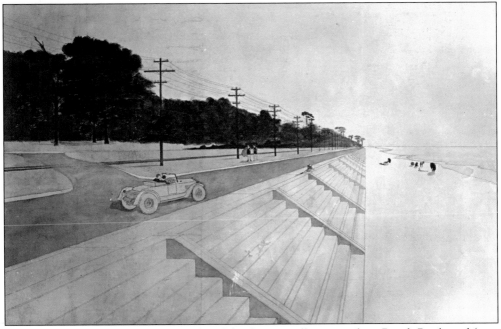

Art Craft Studio produced photographs of the drawings illustrating how Beach Boulevard (now Highway 90) would appear after the seawall was completed. Obviously, a pristine sand beach was also planned. Shaw & Woleben hired C.W. Welch to draw these rendering and reproduce them in larger watercolor art.

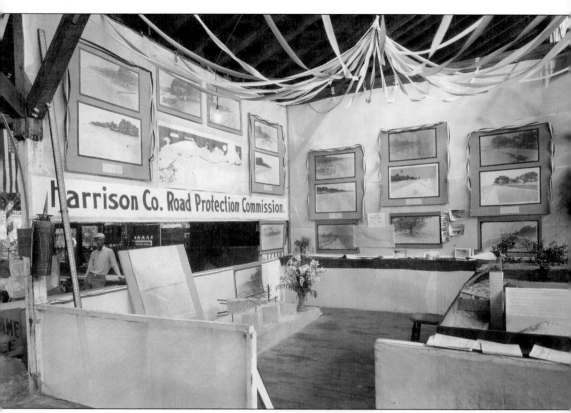

At the annual Harrison County Fair held at the Gulfport fairgrounds, the Shoreline Protection Commission set up an information booth about the construction of the seawall. A model was displayed to show how the concrete step system would work.

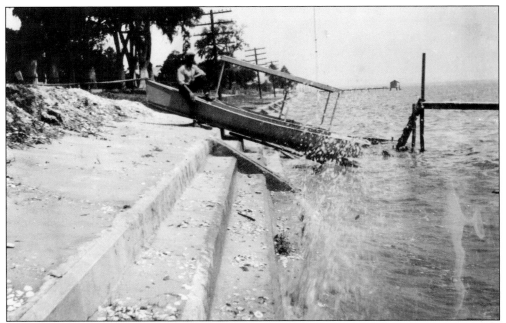

Waves are washing up at high tide as a man prepares to launch a boat into the water. In the background can be seen one of many private fishing piers that dotted the coastline in the 1920s and beyond.

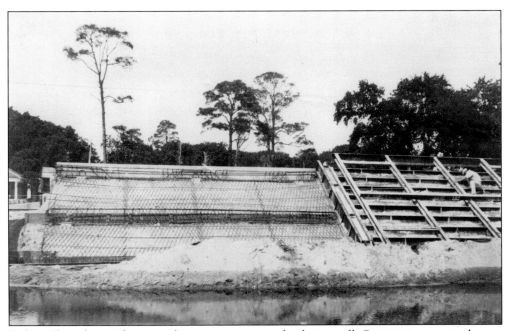

Hobart Shaw designed a stepped, concrete structure for the seawall. Construction created many jobs for local residents. (Courtesy of the Mississippi Department of Archives and History.)

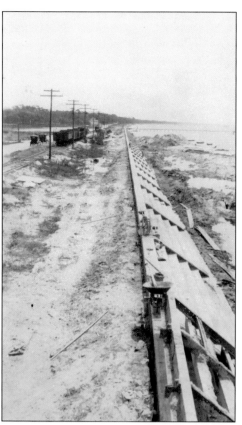

Construction materials were shipped in by railway on a line along the beach. Many carloads of lumber were used to build the frames for pouring the concrete step system. (Courtesy of the Mississippi Department of Archives and History.)

A supervisor watches as workers finish an area of concrete steps. The piece of heavy equipment in the background was used to dredge out the soil. (Courtesy of the Mississippi Department of Archives and History.)

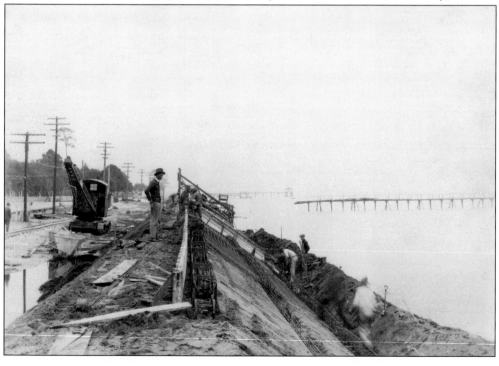

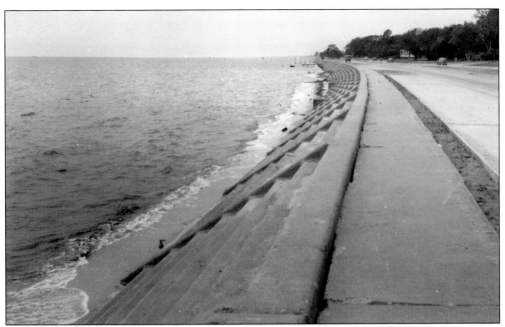

After the seawall was finished, a well-maintained roadway and a concrete walking path ran alongside it. This picture was taken at low tide, revealing some of the natural beach.

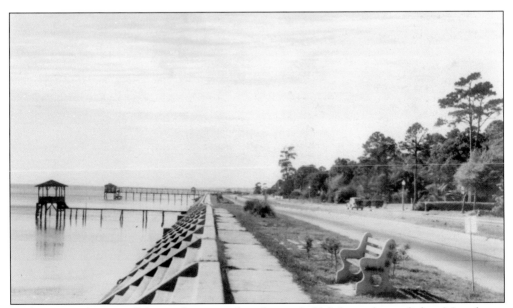

In the 1930s, the seawall featured concrete benches and old-fashioned streetlights. Many home owners had private piers with pavilions for water recreation.

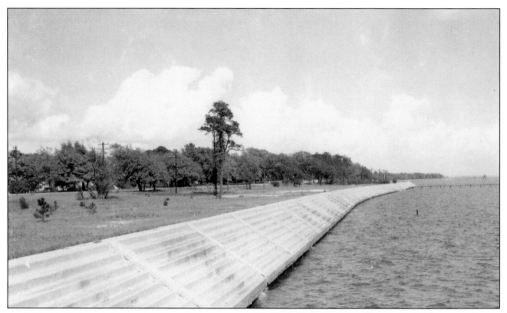

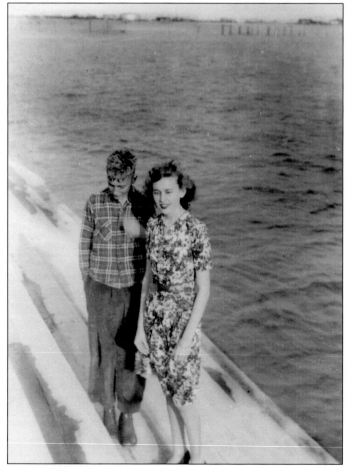

The purpose for constructing a seawall was to stop land erosion. The protection of property and lives was not the primary impetus. A tax of 2¢ a gallon was assessed to pay for the construction. Stability of the water's edge made it possible to build a scenic road (now Highway 90) along the beach. Although there was a natural beach in some areas at any tide level, this was before a man-made beach was created.

At left, a young couple poses on the seawall in the 1940s. The tide appears to be half up the seawall. Depending on the location, in Gulfport there were 12 or 13 steps from the top of the seawall down to the water at low tide.

Four

HURRICANES

Living with the reality of hurricanes is part of living in Gulfport.

A hurricane coming ashore always meant damage. The storms of 1929 and 1947, and others before, resulted in lost property and lives. In addition to the chaos and destruction caused by high winds and tides and tidal surges during an intense storm, the presence of the port itself was more of a potential cause of destruction.

Products set to pass through the port caused varying degrees of damage to structures on shore. For example, in photographs of the aftermath of the 1947 storm, one can see the bags of flour that were swept into residents' yards.

After Hurricane Camille in 1969, winds deposited large rolls of paper onto the lawns of West Gulfport residents.

On August 29, 2005, Hurricane Katrina pushed chicken and pork reserves stored in freezers into the western area of town. In the days following the storm, the smell of rotting chicken and pork was in the air all around town. The worst blow came from containers stored at the facility on Highway 90 (Beach Boulevard). The containers themselves, when pushed by tidal force waves, acted as torpedoes, destroying structures that would have otherwise been safe from wind damage.

The hurricane decimated almost all beachfront homes, while most buildings downtown were either totally destroyed or received devastating damage. Almost all West Side and Mississippi City homes and businesses were gone. Unfortunately, most buildings located near bayous and other waterways received irreparable damage when inundated by the storm surge. The recovery efforts have brought the people of Gulfport, and perhaps the entire nation, together in an effort to rebuild. The purpose now is not to reinvent but to restore Gulfport with a positive bow to its history.

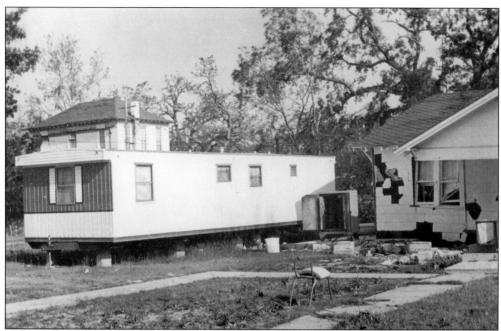

Temporary housing was provided after Hurricane Camille. In October 1969, the first two mobile homes were delivered by the Department of Housing and Urban Development. This first one was for an elderly couple whose total income was approximately $70 a month. They were rescued from their rented home. The husband had suffered a slight stroke and lost his hearing aid and, because the hospital had to close, they stayed at the county jail.

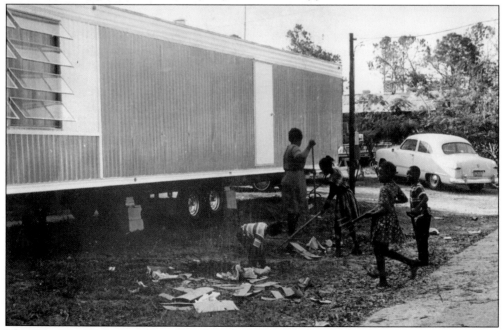

The second mobile home went to Rev. Jonathan Tate. He, his wife, and their four children lived in the unit while they rebuilt their home. The wall plaster inside the house had collapsed, ruining all the furnishings and clothing.

Mayor Philip W. Shaw (left) is pictured in his office after a visit from Hurricane Camille in 1969. He always had clothing for victims who needed help. Mayor Shaw fought a hard successful campaign to win only a few months before having to help his fellow citizens try to recover from this major natural disaster.

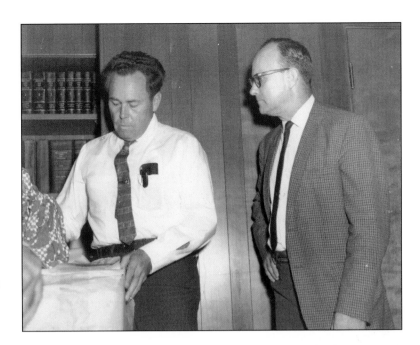

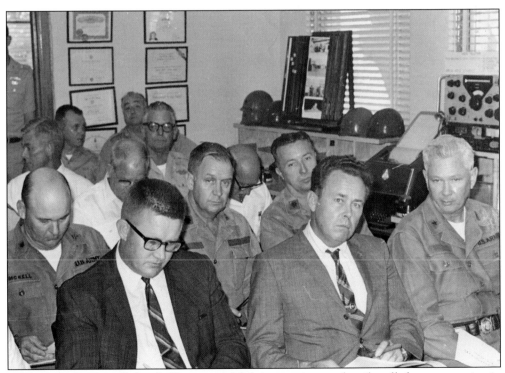

After Hurricane Camille hit Gulfport, a civil defense meeting was hastily called to try to maintain calm after the storm. Gulfport mayor Philip Shaw (middle, first row) was in attendance. A storm the size and impact of Hurricane Camille set the benchmark for destruction and loss of life until the hurricane of 2005.

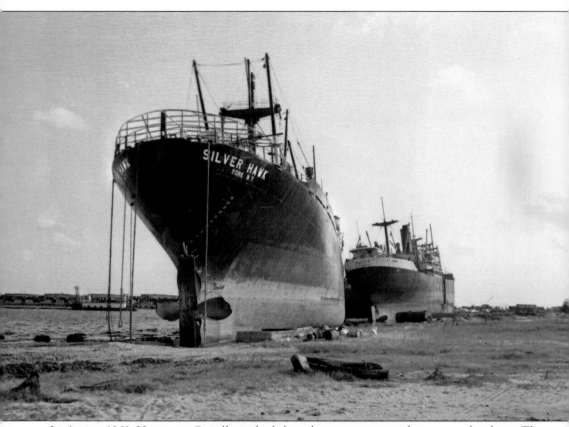

In August 1969, Hurricane Camille pushed these large oceangoing ships on to the shore. The port of Gulfport sustained a great deal of damage from this storm. However, Hurricane Katrina in August 2005 was far more destructive. (Courtesy of Fred Hutchings.)

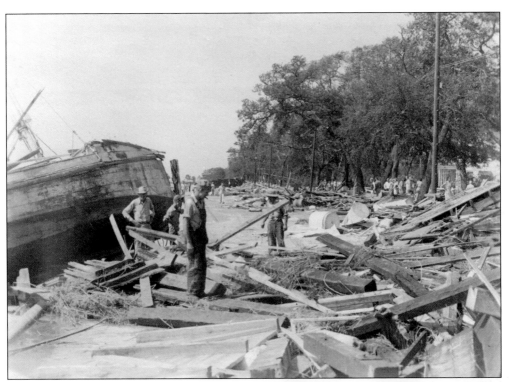

This picture after the hurricane of 1947, taken on September 20 at the intersection of Thirty-eighth Avenue and Beach Boulevard, shows the boat *Frances* washed up with debris.

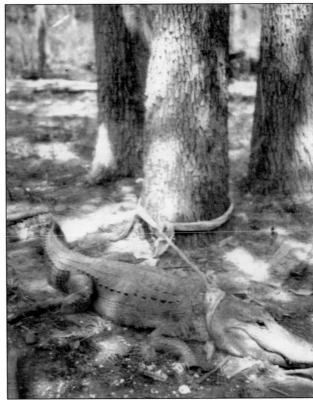

After the 1947 hurricane, an eight-foot-long alligator was captured and tied to a pine tree on the beach near Long Beach. There is no indication as to why this was done.

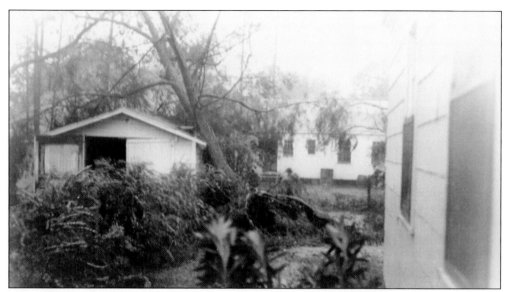

This a picture of tree damage on the property owned by Douglas and Olive Post. Olive (daughter of Hobart Shaw) took this photograph during the storm of 1947. They lived on Kelly Avenue in the Broadmoor section of Gulfport.

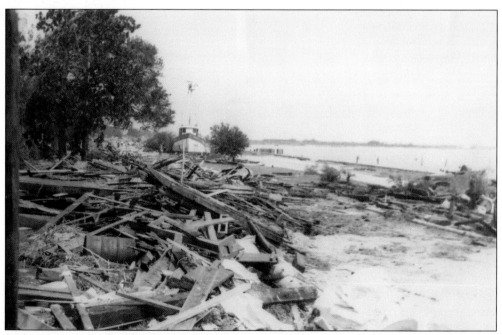

In this picture taken by Olive Post while facing east toward downtown Gulfport, the beach damage can be seen after the storm of 1947. Much of the debris was from piers washed ashore, however, the large boat docked at the port also washed ashore. Yards were littered with rolls of paper and sacks of flour meant for exportation.

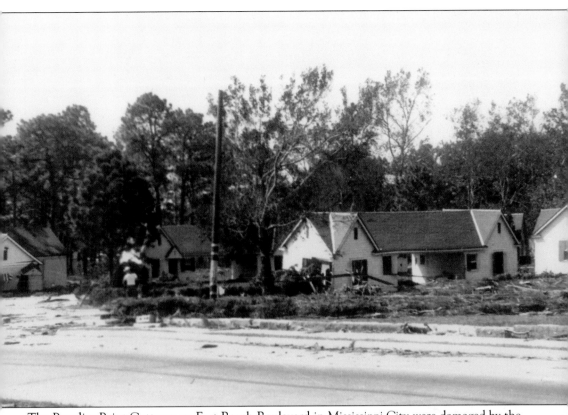

The Paradise Point Cottages on East Beach Boulevard in Mississippi City were damaged by the storm of 1947. Many tourist camps were along East Beach Boulevard (now Highway 90) in Gulfport. This particular property was rebuilt, but it did not survive Camille in 1969.

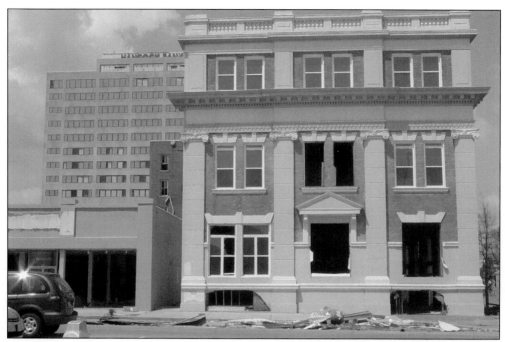

The Kremer building, located at the corner of Twenty-fifth Avenue and Thirteenth Street, survived Hurricane Katrina in 2005, however, the windows were washed out from the tidal surge. This downtown location was submerged under 24 feet of water. (Courtesy of Joe Casey.)

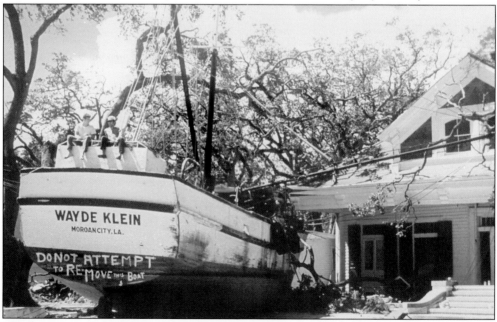

The storm surge from Hurricane Camille in August 1969 pushed large boats across the highway and into the yards of beachfront homes. This was by far the most destructive storm in the coast's history and was to remain so until August 2005. Even though Hurricane Katrina was a larger storm, the losses caused by Camille were immense. Cost of property loss was in the hundreds of millions, and many did not survive. (Courtesy of Paul Jermyn.)

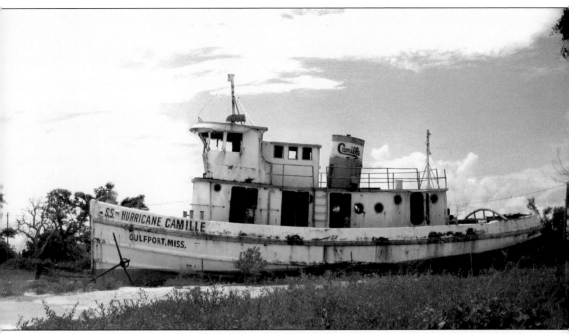

In 1969, Hurricane Camille's winds and waves pushed this tugboat ashore on the north side of the beach road (Highway 90). It was left on the site, becoming a tourist attraction as a gift shop dubbed the USS *Camille*. This photograph was snapped after Hurricane Katrina in 2005. The owners removed the old boat and the land is vacant. (Courtesy of Joe Casey.)

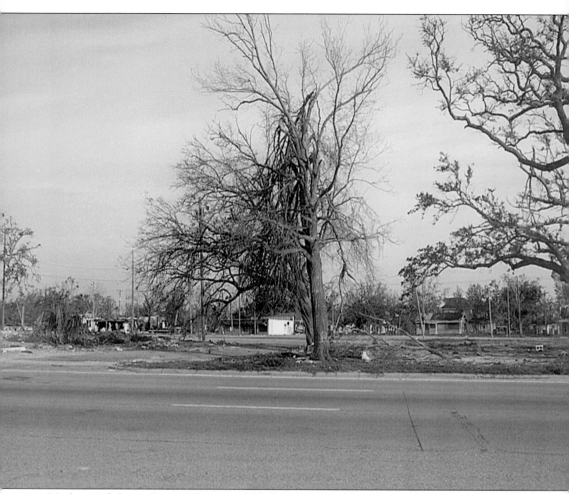

Nothing is left to salvage at this site on Highway 90. In addition to the water and wind, damage to buildings was caused by containers stored at the port as they were pushed into the area by the storm surge. Chickens on their way to Russia were stored in the containers and freezers, and the smell of rotting poultry permeated the air for weeks. (Courtesy of Joe Casey.)

Five

GULFPORT AND THE MILITARY

On June 2, 1942, the US Navy opened its Advanced Base Depot in Gulfport. Civilian construction workers, known as Seabees, have been training at the Naval Construction Battalion since then. The base covers over 1,000 acres one mile northwest of the Port of Gulfport. The depot became a naval storehouse in 1945. Bauxite, an ore used in aluminum production, was stored in huge piles on the site and shipped in through the Port of Gulfport. Today, the base continues to have a positive effect on the economy of the area. Many civilians have permanent jobs at the facility. A true partnership formed between the citizens and the navy personnel stationed there. From building parks and playgrounds to response in disaster situations, the Seabees continue to benefit the area. Many in the military choose to stay on as permanent residents after their service time is completed. The facility is now home to the Atlantic Fleet of the Naval Construction Battalion of the United States.

During World War II, the government opened a training center known as Gulfport Field. The primary purpose was to train airplane mechanics. After completing a basic training regimen, students participated in an intense 19-week course of instruction. For the last eight days, the students transferred to an area dubbed the "Guadalcanal" Graduation Field Test Area. Living in simulated combat conditions with limited tools, men learned to use their own resources and problem solving and survival skills.

Other training took place at the 1,200-acre site. Bomber pilots practiced over-water tactics. Another section of land was for the 1,308th Signal Pigeon Company. Stationed there were women from the 752nd Women's Army Air Corps (WAAC) Post Headquarters Company. Members of the African American 82nd Aviation Squadron and the 935th Quartermaster Platoon also used Gulfport Field for training.

Gulfport Field was a thriving military installation. A fully staffed hospital and dental unit provided health care treatment. The post location boasted theaters, shops, a library, telegraph offices, a sports arena, and a recreational building, as well as five chapels. Recreational activities included boxing, baseball games, and singing. There were also a radio station and a newsletter.

After the war ended, the US military gave the property to the city, which annexed it in 1951. Gulfport-Biloxi International Airport and the residential subdivision Bayou View are located on parts of the property today.

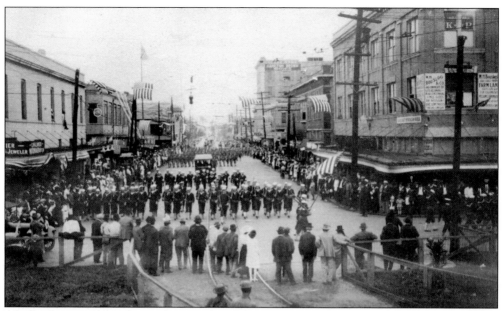

Above, throngs of people watch a parade celebrating the World War I victory in the streets of Gulfport. This view is facing north on Twenty-sixth Avenue. The Olympia Café is on the left, and Jones Bros. Drug Store is on the right. The W.H. Bouslog Company advertises land, pecans, and oranges for sale on their billboard. (Courtesy of Paul Jermyn.)

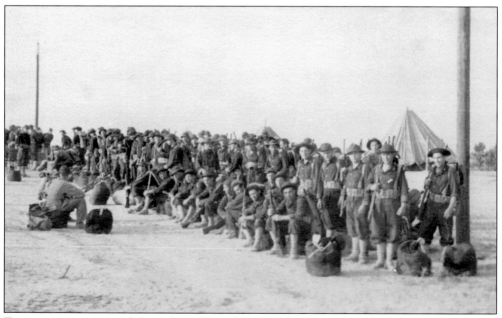

Troops were transported through Gulfport by trains for entry into World War I. Just outside Union Station, tents were set up, as troops from the surrounding cities and farms gathered to be shipped north for their assignments. (Courtesy of Paul Jermyn.)

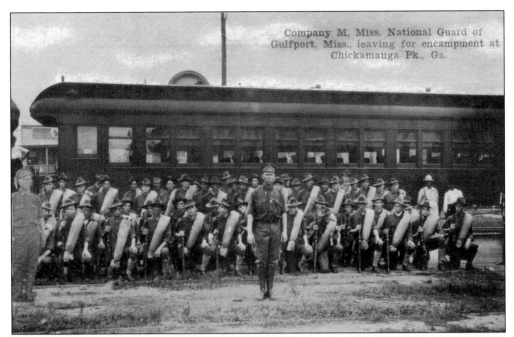

A group of Mississippi National Guardsmen pose before a troop train, ready to set out for assignment for service in World War I. The Union Station Depot was a busy place during this war. The Gulf and Ship Island Railroad scheduled passenger and freight trains to accommodate the military arrivals and departures. (Courtesy of Paul Jermyn.)

Naval training took place during World War II at the Naval Base in Gulfport, then known as the Navy Yard. The influx of the military during war and peace times helped the economy of Gulfport. (Courtesy of Paul Jermyn.)

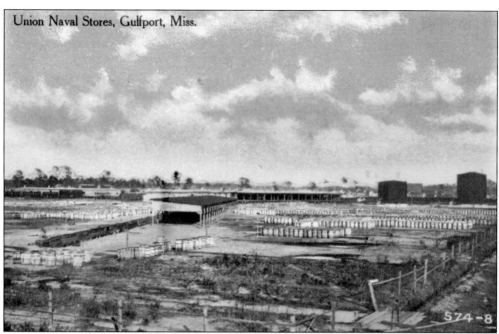

Since World War II, the navy base at Gulfport has been a storage site for equipment. In the 1950s, large amounts of bauxite were shipped in through the Port of Gulfport to be stored there. Bauxite is a component in the production of aluminum. (Courtesy of Paul Jermyn.)

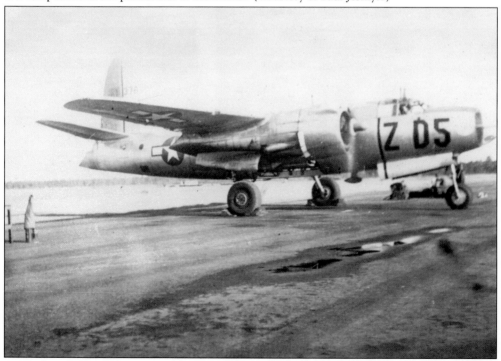

Besides aircraft mechanics, airplane pilots also trained at Gulfport Field. Bomber pilots used the nearby Gulf of Mexico to practice over-water procedures. The Gulfport-Biloxi International Airport is located on a portion of the property. (Courtesy of Paul Jermyn.)

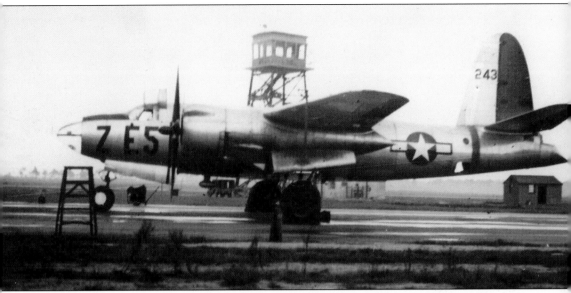

A training plane takes off from Gulfport Field during World War II. The Mississippi Gulf Coast's subtropical weather was one reason troops trained here. The climate apparently was similar to that of Guadalcanal. Planes were kept under camouflage cover at the airport.

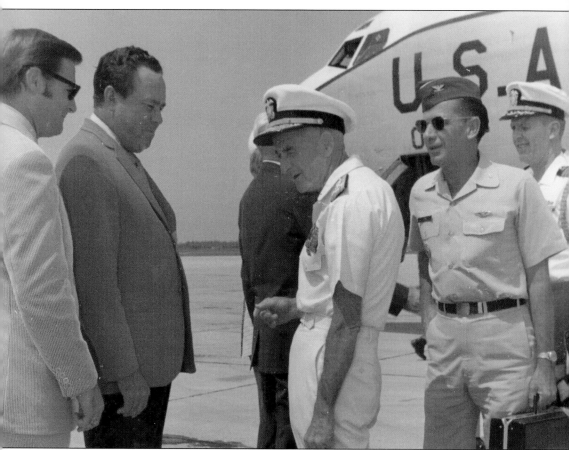

In the early 1970s, Philip W. Shaw Sr. (second from left), mayor of Gulfport, greeted Adm. John McCain Sr. (third from left) on a stopover at the Gulfport airport. Admiral McCain was the chief of naval operations and the father of John McCain Jr., a US senator. (The ancestors of both the Shaws and McCains were from Carroll County, Mississippi.)

Six

ENTERTAINMENT
AND TOURISM

As part of his plan to develop a city, Capt. Joseph T. Jones included a resort hotel. A titan of industry, Jones understood the importance of access to leisure activities for the wealthy investors he hoped to attract to Gulfport.

By building the Great Southern Hotel, he provided instant respite for northern visitors. The resort offered hunting, fishing, boating, and golfing opportunities. Located very close to the Gulf of Mexico's coast, it boasted magnificent views and cool breezes. The hotel itself provided nightly entertainment, with live music for dancing. There was a billiards room open to the female guests. The close proximity to New Orleans, Louisiana, meant that New Orleanians often spent holidays on the Mississippi Gulf Coast.

Gulfport later had many family-friendly beachfront accommodations. Cabins across Highway 90 (the beach drive) served as tourist camps. Family-oriented activities included an oceanarium, Marine Life, where dolphins performed hourly and trainers showed off bird acts. The finale was a ride on a little tour train around the small-craft harbor and the shipping terminal.

The mid-1990s brought casino gaming to the Mississippi Gulf Coast, and Gulfport was no exception. The municipality voted in favor of casinos. The Grand Casino had a gaming barge, a parking garage, and two hotels. The Copa Casino had a ship and, later, a barge location.

Festivals were abundant on weekends, especially in the spring and fall. Fourth of July activities included the Fishing Rodeo established in 1947. Essentially, it was a fair with prizes awarded for fish caught in various categories. The event ended with a fireworks display on the beach.

Tourism has historically been a major industry in Gulfport.

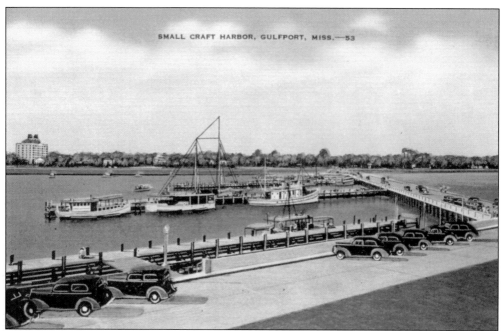

This postcard shows the small-craft harbor before the sand beach was added. The building in the background is the Markham Hotel. The boat docks here were provided for fishermen and shrimpers. The recreational boats were docked at the yacht club at the end of this bridge. Car tags reflect visitors from many other states. (Courtesy of Paul Jermyn.)

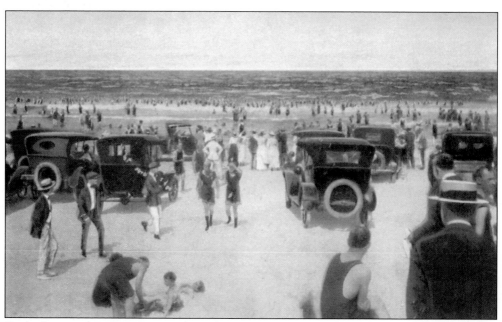

Sunbathers in the 1920s were modesty dressed, and cars were casually parked on the natural beach. Before the seawall, there were sand beaches. In the following years, the water was dredged to replenish this tourist attraction. (Courtesy of Paul Jermyn.)

Capt. Joseph T. Jones's son Albert (or "Bert") was an avid golfer. The Joneses enjoyed golfing at the Great Southern Golf Club. A part of the Great Southern Hotel, the course was located on the beachfront of what is now Highway 90, east of Gulfport. The buildings were destroyed by Hurricane Katrina in 2005. (Courtesy of Paul Jermyn.)

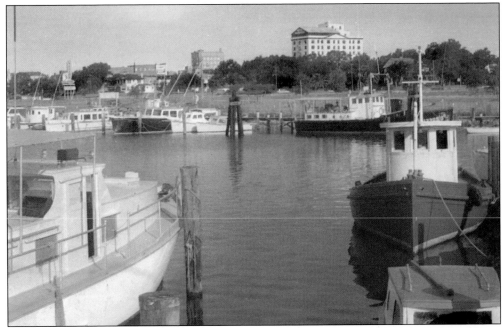

The small-craft harbor in 1960 held wooden pleasure boats and trawlers. A day or overnight trip to one of the islands was a popular adventure. In this image facing north is Jones Park and the Markham Hotel. In the background stands the original Hancock Bank and a sign for Marine Life. (Courtesy of Paul Jermyn.)

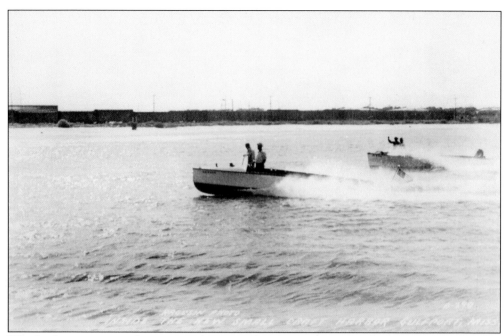

Wooden boats zip across the waves in the image above. Powerboat races became a popular activity. In fact, a current powerboat race, Smokin' the Sound, has promoted this sport again. (Courtesy of Paul Jermyn.)

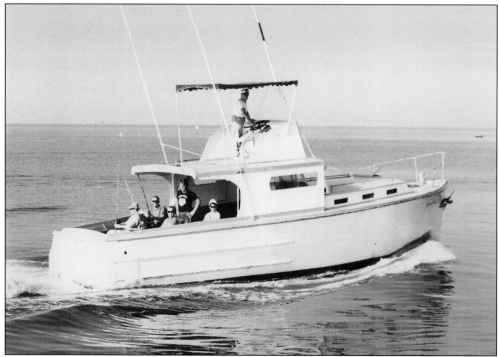

Deep-sea fishing was very popular. Piloted from the flying bridge, this fishing excursion probably featured trolling for Spanish mackerel. Large fishing rods were needed to land a big lemon fish. Fishing was excellent almost everywhere in the saltwater. (Courtesy of Paul Jermyn.)

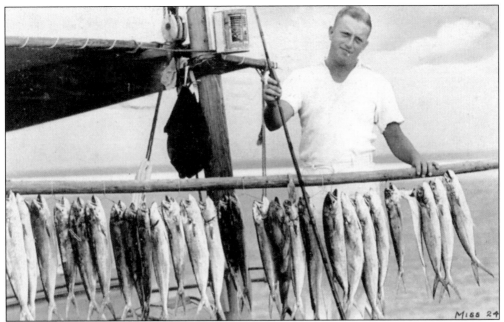

Above, a young fisherman shows off his catch. There were no limits, as fish were plentiful. Gulfport hosts an annual Fishing Rodeo that takes place over the Fourth of July weekend. It features several days of fishing and culminates with a large fireworks display in Jones Park. The event was moved in 2006 after the Hurricane Katrina in 2005, but the festival may return to Gulfport by 2011. (Courtesy of Paul Jermyn.)

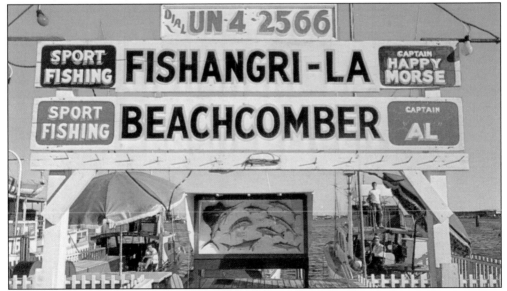

Charter boats operated along the piers south of Jones Park, and for years, many families made taking tourists deep-sea fishing their livelihood. For a day or weekend trip, the boat owners provided their clients with fishing tackle, food, drinks, and, hopefully, fish to take home. Fishing was a popular side trip for convention attendees from other parts of Mississippi or other states. The hurricane in 2005 and the oil catastrophe in 2010 adversely affected this tourist industry. (Courtesy of Paul Jermyn.)

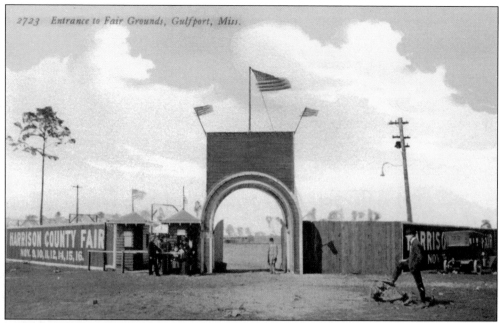

In the early 1900s, Gulfport hosted a county fair. The fairgrounds' location, west of downtown near the corner of Railroad Street and Thirty-eighth Avenue, is now the setting for Milner Stadium, the home field for sporting events of the Gulfport school system. There is no longer a fair. (Courtesy of Paul Jermyn.)

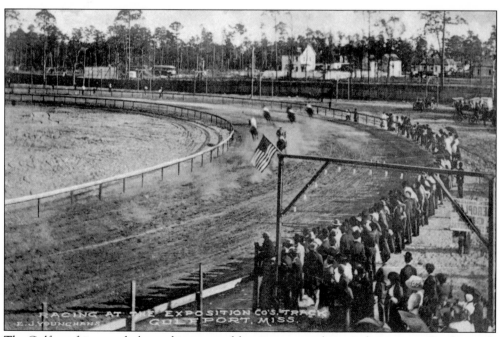

The Gulfport fairgrounds, located just west of downtown, were home to horse races. On the north side of the railroad track and bounded on the east by Thirty-eighth Avenue, the races drew tourists from New Orleans, Louisiana, and Mobile, Alabama. (Courtesy of Paul Jermyn.)

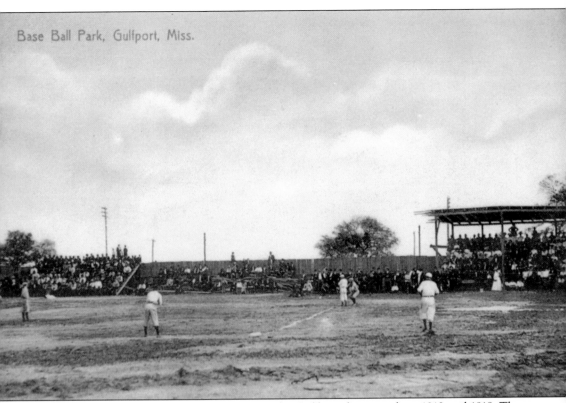

Base Ball Park, Gulfport, Miss.

The Detroit Tigers held their spring training at the Gulfport fairgrounds in 1912 and 1918. The location of the fairgrounds is now the site of the Milner Stadium and track and baseball fields. A new elementary school and middle school are also there. Gulfport High School football games have been played there for many years. (Courtesy of Paul Jermyn.)

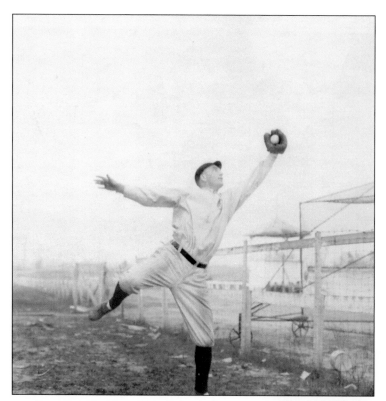

Baseball great George Moriarty was at the Detroit Tigers' training camp held at the Gulfport fairgrounds in the spring of 1912. At the time, Moriarty, who had played with the famous Ty Cobb, was an umpire. (Courtesy of Paul Jermyn.)

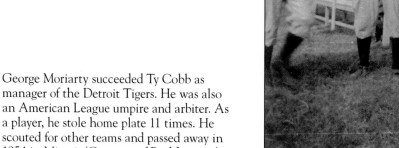

George Moriarty succeeded Ty Cobb as manager of the Detroit Tigers. He was also an American League umpire and arbiter. As a player, he stole home plate 11 times. He scouted for other teams and passed away in 1954 in Miami. (Courtesy of Paul Jermyn.)

Seen here in the 1950s are sunbathers and a young airman who was stationed at Keesler Air Force Base in Biloxi. Many young people went through their training on the coast before being sent on overseas assignments. The note on the back of the picture reads, "Beach beauties by day, bar maids by night." Their identities are unknown.

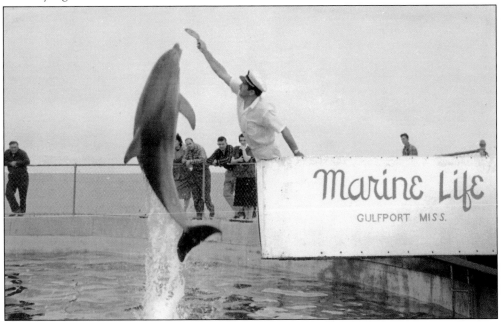

Marine Life, located in Jones Park close to water near the Gulfport Yacht Club, was a longtime tourist attraction. There was an indoor tank with large glass walls and massive sea turtles. Many species of fish were on display. Adding to the adventure were acts by trained birds and a tour train ride around the small-craft harbor. (Courtesy of Paul Jermyn.)

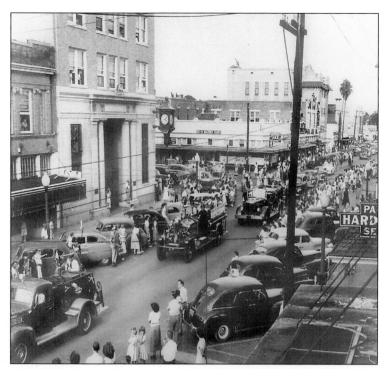

The Gulfport High School Homecoming Parade crosses Twenty-fifth Avenue on Fourteenth Street downtown. This early-1950s photograph shows crowds in front of the Hancock Bank building. In the days before air-conditioning, the windows of the bank were open on the higher floors. The JAX beer sign advertises "Bottled Beer." Fire trucks lead the parade. (Courtesy of Paul Jermyn.)

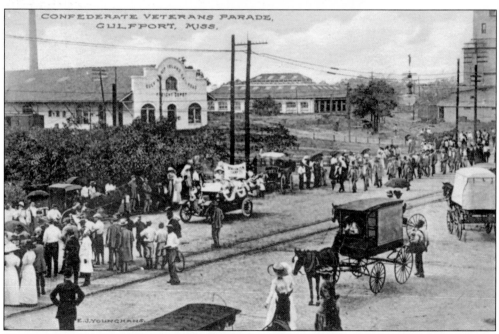

The Veterans Day Parade in downtown Gulfport passes in front of the Gulf and Ship Island freight depot. Unlike other towns along the coast, Gulfport did not host Mardi Gras parades until much later. Today, the Krewe of Gemini holds parades for Mardi Gras on the streets of downtown Gulfport. St. Patrick's Day is celebrated with a parade sponsored by Quota International of the Mississippi Gulf Coast. (Courtesy of Paul Jermyn.)

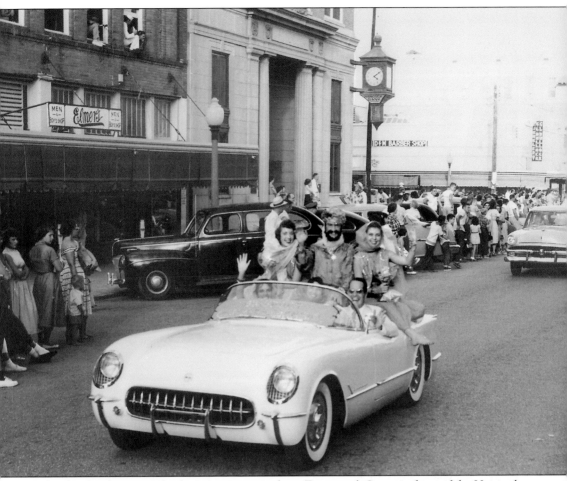

No beads were thrown in this homecoming parade on Fourteenth Street in front of the Hancock Bank. The brand-new 1950s Corvette carries a couple of would-be genies. People are looking out the open windows of the insurance company next to Hancock Bank. (Courtesy of Paul Jermyn.)

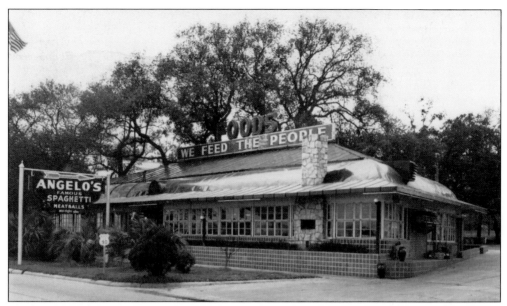

Angelo's Italian restaurant was owned by a Greek family. Located on Highway 90 (West Beach Boulevard), the eatery featured spaghetti and meatballs, steaks, and seafood. A carryout area around back served great Italian pizza. Vrasel's Fine Foods is now located on the site. (Courtesy of Paul Jermyn.)

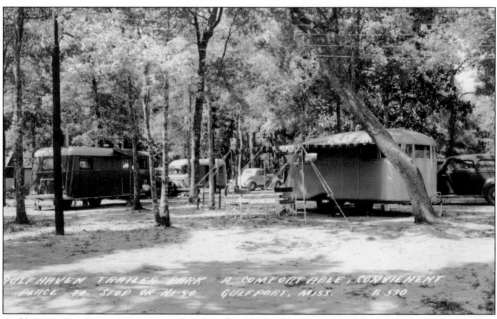

Gulf Haven Trailer Park was located on East Beach Boulevard and catered to the tourists traveling with trailer homes. Just a few steps across Highway 90 was the man-made sand beach. Trailer parks and tourist camps became affordable vacation alternatives in the 1940s and 1950s. (Courtesy of Paul Jermyn.)

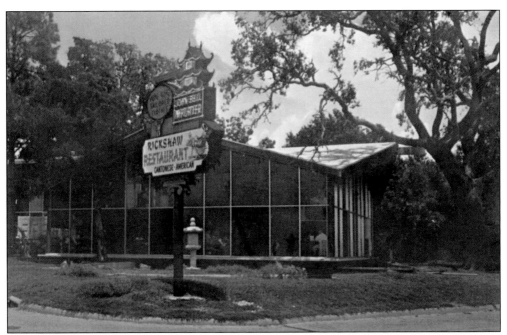

The first Asian restaurant in Gulfport was Rickshaw Restaurant. It was located on US Highway 90, just west of Courthouse Road in East Gulfport (formerly Mississippi City), in the same building as John Bell Importers. The building later became a lighting fixture store called Carrousel Point. After Katrina, condominiums replaced the demolished structure. (Courtesy of Jim Miller.)

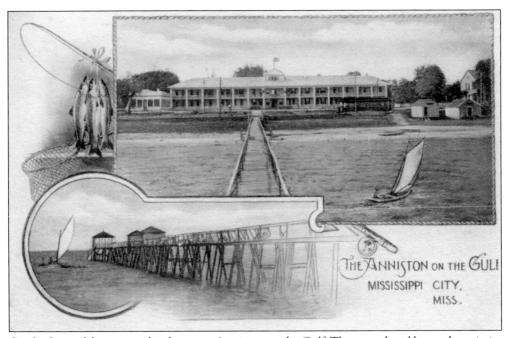

On the front of this postcard is the resort Anniston on the Gulf. The resort hotel boasted proximity to fishing and luxurious accommodations. The postcard depicts the pier extending out into the gulf. (Courtesy of Paul Jermyn.)

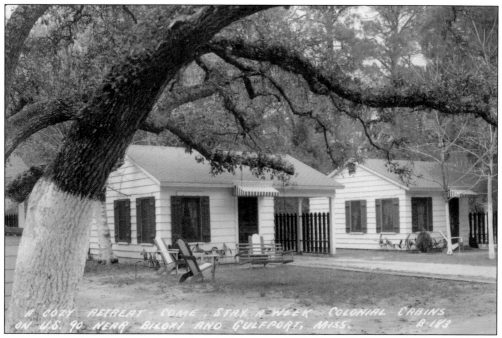

Colonial Cottages offered a different kind of tourist destination. These individual cabins across the street from the beach appealed to vacationing families during the busy peak season. (Courtesy of Paul Jermyn.)

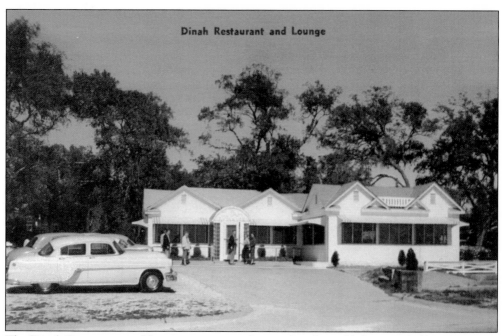

The Dinah Restaurant and Lounge was a popular east beach establishment. Gulfport's tourists consisted mainly of families who stayed at the beachfront motels and tourist courts. Cafés like the Dinah provided lunches and dinners at moderate prices. (Courtesy of Paul Jermyn.)

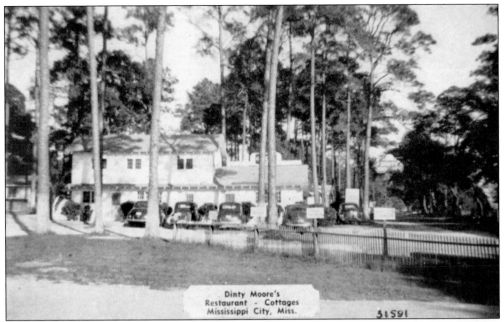

Dinty Moore's Mississippi City location was one of a chain of diners located around the country. Other Dinty Moore diners documented were in Fort Smith, Arkansas, and Providence, Rhode Island. James Moore adopted the name "Dinty" from the comic strip *Jiggs and Molly*. Dinty Moore was the name of the tavern keeper in the comic strip. (Courtesy of Paul Jermyn.)

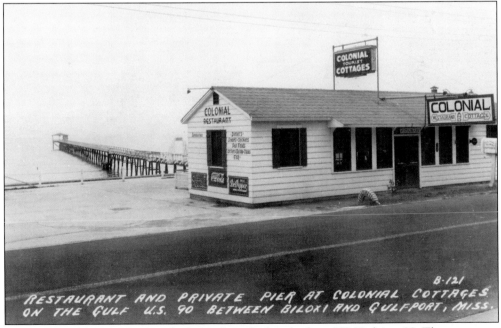

It was unusual for businesses to be located on the beach along US Highway 90. The restaurant for Colonial Cottages was on the beach, and the cabins were across the road. Restaurants thrived by serving seafood fresh from the docks. This East Gulfport location had a pier for its customers. (Courtesy of Paul Jermyn.)

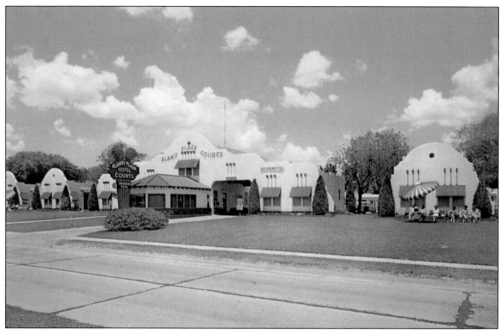

Alamo Plaza Courts was an extremely popular tourist destination on the beach in Mississippi City. The Alamo Plaza Courts was located on the service drive north of Highway 90. It had shuffleboard courts and a swimming pool. The owners sold the land and demolished the motel. A multistory condominium complex occupies the site. (Courtesy of Paul Jermyn.)

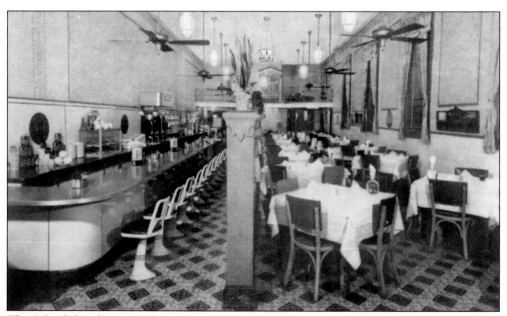

The Splendid Café was on the corner of Twenty-sixth Avenue and Thirteenth Street, north of the Great Southern Hotel. The owners operated a hotel upstairs. This interior picture shows the café and lunch counter as it appeared in the 1920s. (Courtesy of Paul Jermyn.)

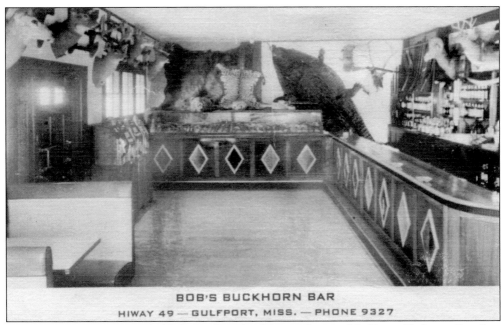

BOB'S BUCKHORN BAR
HIWAY 49 — GULFPORT, MISS. — PHONE 9327

Bob's Buckhorn Bar was probably located north of the city limits of Gulfport. Highway 49 within the city limits was referred to as Twenty-fifth Avenue. There were rumors of gambling in bars outside the city. The polished wood and animal trophies may indicate an affluent clientele. (Courtesy of Paul Jermyn.)

This 1960s photograph of Stevens Seafood Market shows one of the trailer parks that were made up of inexpensive residential homes. Trailers were purchased and moved to parks, where the owners paid monthly rent. The trailer inhabitants usually could not afford other housing, but building codes began to eliminate trailer parks in the residential areas of Gulfport. (Courtesy of Paul Jermyn.)

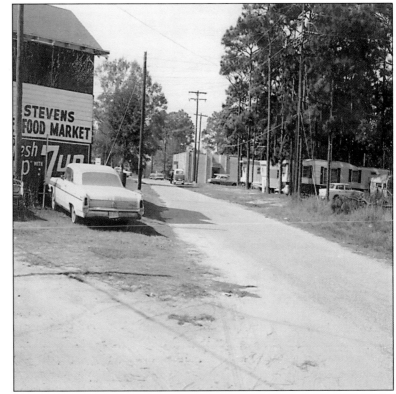

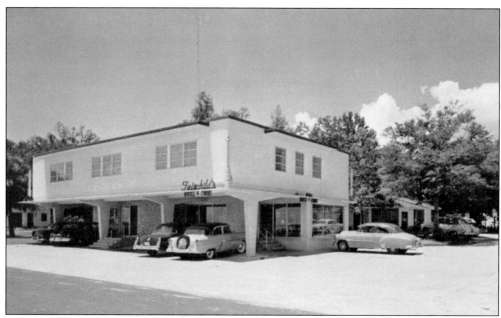

Fairchild's Restaurant and Motel was located north of Highway 90 in Mississippi City. Like most motels, Fairchild's featured a restaurant. The business was sold and eventually lost to Hurricane Katrina. (Courtesy of Paul Jermyn.)

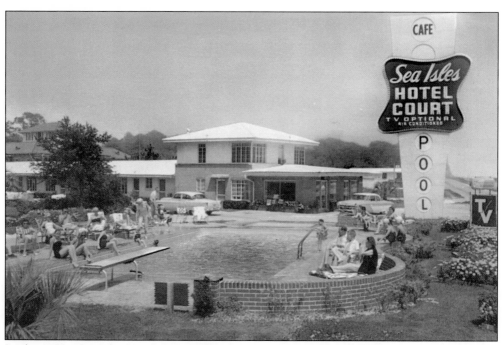

In the 1950s, Sea Isles Hotel Court offered a restaurant and pool. Televisions were optional. However, air-conditioning was provided. At this time, motels began vying for customers by advertising the amenities. (Courtesy of Paul Jermyn.)

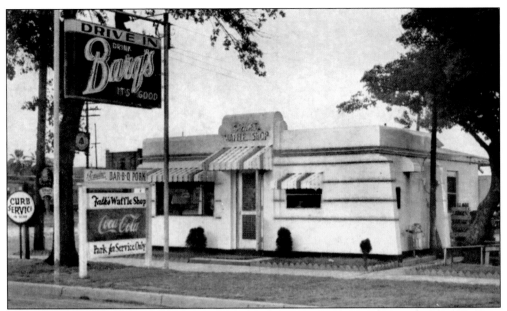

One of the important things to notice about Falk's Waffle House is not the waffles but the root beer. At that time, Barq's Root Beer was bottled in Biloxi and sold exclusively on the Mississippi Gulf Coast. The curb service was also a sign of the times. (Courtesy of Paul Jermyn.)

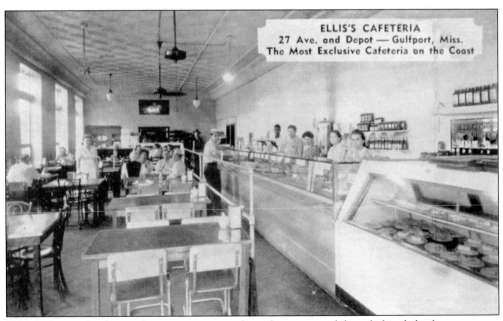

Ellis Café was the first cafeteria in town, and employees served from behind the long counter, similar to the lines in public schools. The Ellis Café near the train depot on Twenty-seventh Avenue was probably popular with passengers departing from the trains at Union Station Depot. (Courtesy of Paul Jermyn.)

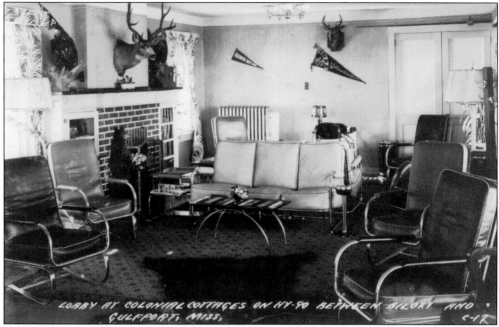

Nearby on West Highway 90 were Colonial Cottages. Their motto was "From the Cheapest that is Good to the Best to be had." There was a private pier for fishing. Other features were Beautyrest mattresses, Axminster art squares, tile baths, and gas-steam heat. All cottages were "sealed with Celotex. Cool in summer—warm in winter." The lobby displayed a poster from Ranier National Park. (Courtesy of Paul Jermyn.)

This is an inviting image of a wooden swing at the Fernwood Cottages. The Fernwood community was one of the last areas annexed by the City of Gulfport. This once rural community is the eastern limit of Gulfport. The Fernwood School, located at the corner of Debuys and Pass Roads, was in Gulfport but was considered a part of the Biloxi School District in 1969. (Courtesy of Paul Jermyn.)

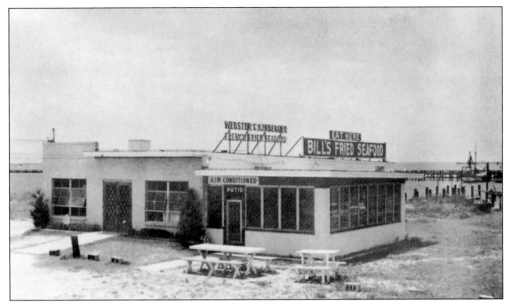

Webster and Kinberger seafood diner was located on the water side of Highway 90. The land in this area was unaffected by the seawall construction because it was located just north of the east pier. Destroyed by Hurricane Camille, a seafood market was located there until replaced by the Grand Casino Parking Garage. (Courtesy of Paul Jermyn.)

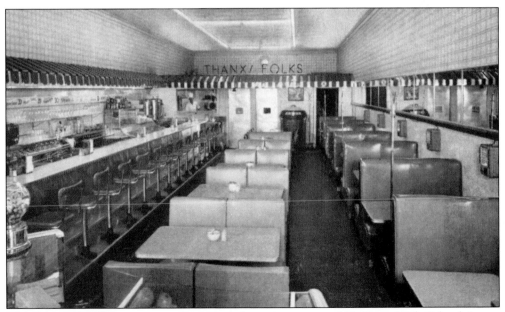

The Commodore Restaurant took its name from the mascot of Gulfport High School. It was located a few businesses north of the Paramount Theatre. The Commodore's interior was clean and welcoming, and like other downtown eateries, the restaurant catered to the lunch crowd. (Courtesy of Paul Jermyn.)

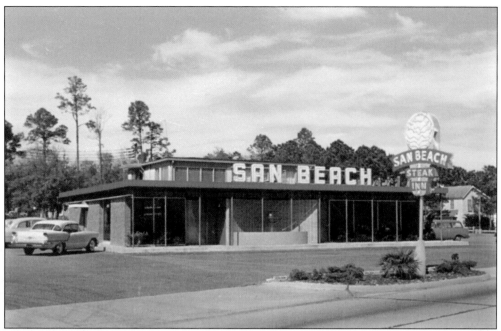

The San Beach Steak Inn was a popular café located on Highway 90 (Beach Boulevard). A precursor to the steakhouses of the 1970s, the San Beach was known for its generously sized burgers, steaks, and, of course, seafood. This café was a popular hangout for the local residents. (Courtesy of Paul Jermyn.)

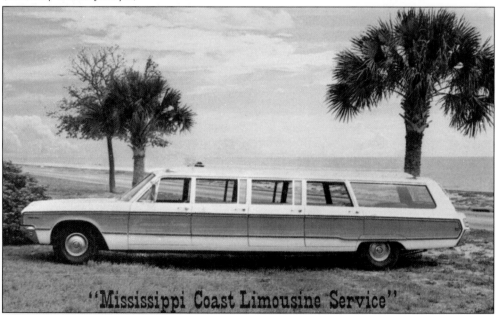

Limousine service was available even before the influx of casinos made the sight of a limousine seem commonplace. The Mississippi Coast evolved into the Coast Liner transportation system, the driving force behind bringing tourists to the Mississippi Gulf Coast from the New Orleans tourist market. Later, vans transported visitors from the airport in New Orleans to destinations in Gulfport. (Courtesy of Paul Jermyn.)

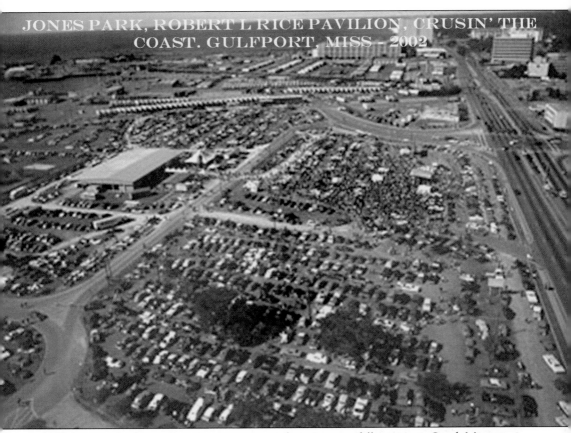

JONES PARK, ROBERT L RICE PAVILION, CRUSIN' THE COAST. GULFPORT, MISS – 2002

In 1995, business leaders and tourism interests sought to increase fall tourism in South Mississippi. Cruisin' the Coast is an event meant to showcase classic and antique automobiles in a venue that does not make judging the main purpose. The goal is to show off the cars. The registration for the cruise was in Jones Park. The annual event has been a boon to the economy of the entire Mississippi Gulf Coast. Over 5,000 antique and classic cars registered in 2009, and although participation declined because of the hurricane, attendance is increasing again. (Courtesy of Joe Casey.)

In the 1990s, the Mississippi River at New Orleans was unable to accommodate the docking of cruise ships. The large cruise vessel *Sensations* landed at the east pier in Gulfport as an alternate port. Although much speculation arose regarding Gulfport as a cruise ship destination, nothing has happened to make this a reality. Since then, Mobile, Alabama, has built and implemented a large cruise ship facility.

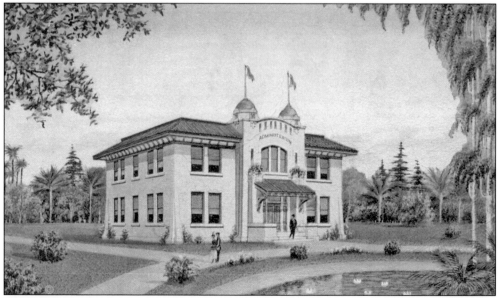

The Gulfport exposition was planned for a centennial celebration of statehood of Mississippi. A campus of many stucco clay-tiled roof buildings was constructed in anticipation of the event. However, when the United States entered into World War I, the centennial celebration was cancelled. The buildings housed the Veterans Administration Mental Health Center for many years. After Hurricane Katrina caused damage, the federal government turned the property and all the buildings over to the city for development.

Seven

PEOPLE, PLACES, AND THINGS OF GULFPORT

While this pictorial is in no way a complete look at the history, it is a glimpse into the past of Gulfport, Mississippi. This chapter, devoted to images that did not quite fit in previously, is the rest of the story.

These are pictures typical of everyday life in this American town. Schools, businesses, and, of course, the people who lived and worked in the town are important. Gulfport has seen progress in education and health care. There are two public school systems and a community college. Private schools and colleges add their own dimension to education.

Rotary and the Gulfport Women's Club are only two examples of the many service organizations in town that make up the backbone of this community.

People remember buildings. However, they also have memories of the innocent faces of schoolchildren, the smell of bread from the bakeries, the striking clock on the Hancock Bank, and the smell of salt from the gulf waters. Pictures and memories remain of snow falling in this subtropical climate and the celebration when Sears, Roebuck, and Co. opened with an escalator.

The new casino is there, but so is the Gulf and Ship Island Railroad building erected by Capt. Joseph T. Jones as a promise of great things for Gulfport, Mississippi.

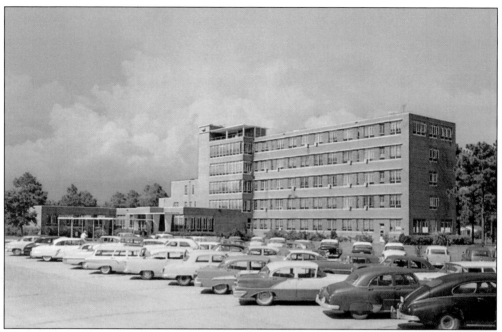

Memorial Hospital at Gulfport is jointly funded through the city and county governments. The city's only nonprofit hospital, preceded by the King's Daughters Hospital and the hospital at the navy base, this facility is now a top-notch medical center. It is located north of the railroad tracks east of Broad Avenue. (Courtesy of Paul Jermyn.)

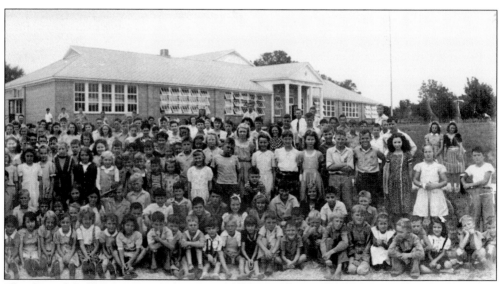

The City of Gulfport annexed the area north of town known as Orange Grove. Seen here is an early photograph of Orange Grove Elementary students and faculty in front of their school building. (Courtesy of Henry Arledge, Harrison County School District superintendent.)

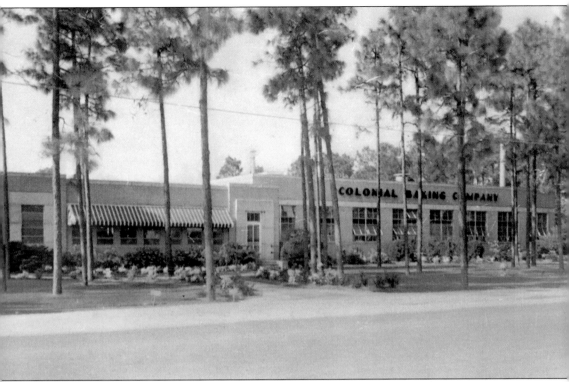

Colonial Baking Company was located on Pass Road in Gulfport. The people who drove by in their cars enjoyed the aroma of baking bread. During the Christmas season and amid holiday lights, Santa Claus took toy requests from children. Each child received a miniature loaf of Colonial bread. (Courtesy of Paul Jermyn.)

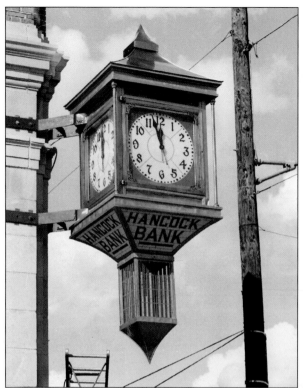

The Hancock Bank, located at the downtown corner of Twenty-fifth Avenue and Fourteenth Street, displayed a clock from the corner of its old building. Hancock Bank bought the facility after the original bank located there closed its doors as a result of the Great Depression of the 1930s. (Courtesy of Hancock Bank Archives.)

This striking clock still hangs outside the original bank building. (Courtesy of Hancock Bank Archives.)

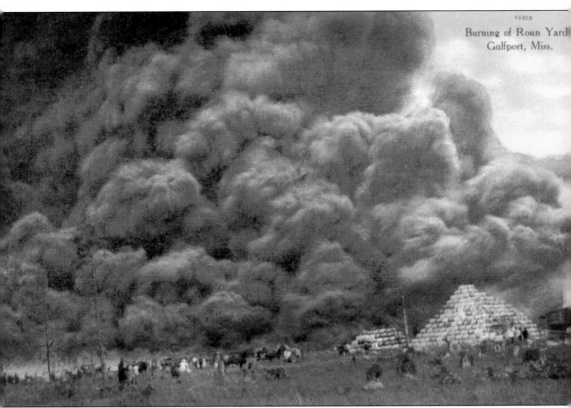

The lumber industry was an important one in Gulfport. Exporting timber and other products was a major influence in the development of early Gulfport. Resin, a by-product of the treatment of lumber, is a highly flammable substance. The resin yard near Twenty-eighth Street and Thirtieth Avenue caught fire, destroying stores and causing astronomical insurance claims for the time. (Courtesy of Paul Jermyn.)

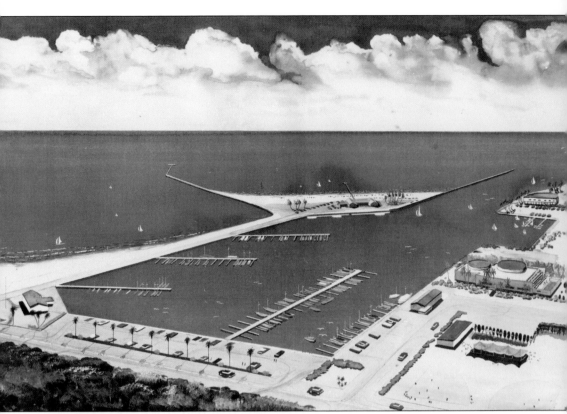

An aerial rendering shows the potential growth of Gulfport's small-craft harbor. Included are long fishing piers and a large entertainment facility that never came to be. Marine Life's building and tanks are on the right.

The building of the *Daily Herald* newspaper was sold to a group of attorneys after the business moved to the Gulfport side of Debuys Road. The law firm of Bryant-Stennis chose to restore the structure. This photograph is of the lobby area and shows the exposed brickwork from the 1920s. Hurricane Katrina destroyed the building in 2005.

Phillips Colleges was established as a class to teach girls the skills necessary to become secretaries. Photographed below is a typing lab. Phillips Colleges went on to become a nationally recognized facility for office training and various other trades, with locations nationwide.

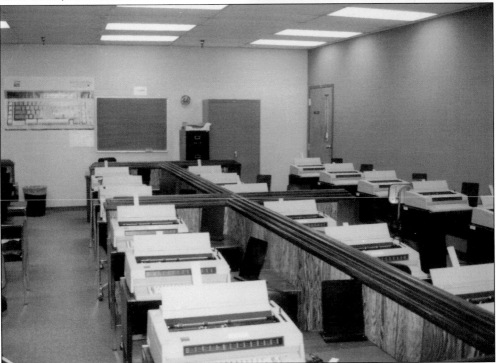

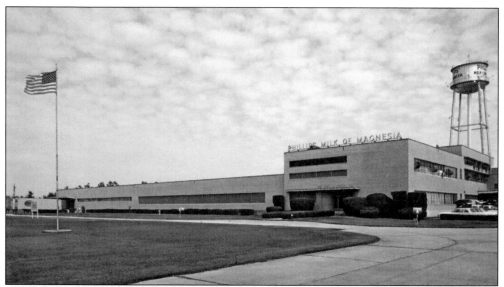

The Phillips Milk of Magnesia plant still processes its product at a factory located on Highway 49, just within the city limits. The building is a large distribution facility. The brick-and-mortar construction helped it withstand damage from Hurricane Katrina in 2005.

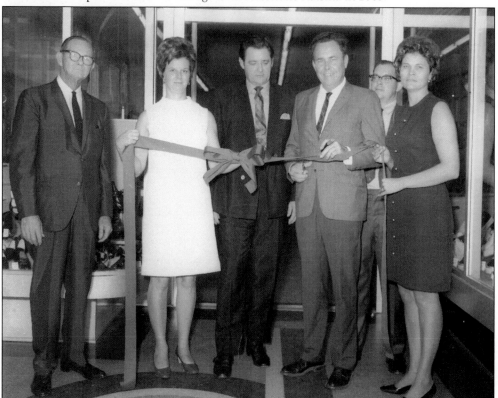

A shopping plaza, built after the Great Southern Hotel was demolished, was home to a number of New York–based retailers. This photograph shows the then mayor of Gulfport, Philip W. Shaw (fourth from left), at the ribbon-cutting ceremony for Kinney Shoes' new Gulfport location.

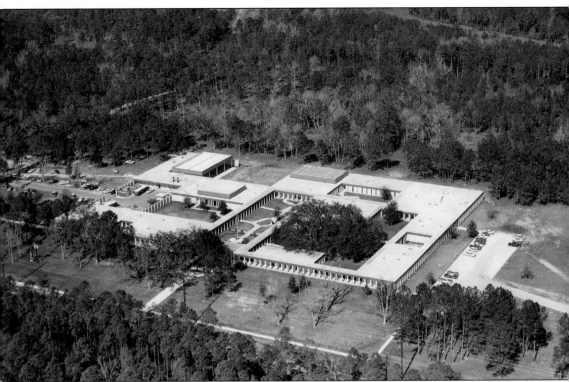

The Jefferson Davis Campus of the Mississippi Gulf Coast Community College opened in Gulfport in 1965. The campus was designed to meet the needs of graduating students not yet prepared to meet the challenges of a large state university. The University of Southern Mississippi offers an alternate path, including the first two years at the MGCCC campuses. (Courtesy of Mississippi Gulf Coast Community College C.C. "Tex" Hamill *Down South* Magazine Collection.)

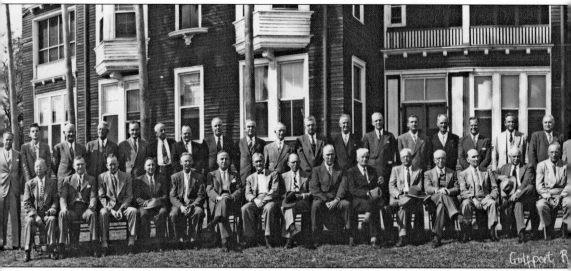

The Gulfport Rotary Club met on Thursdays for a luncheon meeting at the Great Southern Hotel. This picture was taken in front of the hotel in 1941. There is little doubt that there are many government and community leaders in this image. The elderly lady in the middle of the group was the pianist; at the time, singing was an important part of the weekly meeting. Among

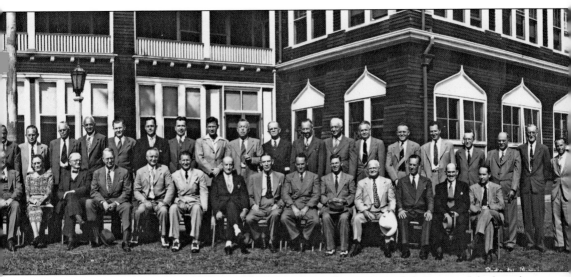

the members is the young Donald Sutter, who later rose to the position of chairman of the board of Hancock Bank. In order to make this panorama, photographic shots were captured one at a time and then pieced together. Notice that Sutter stands at both ends. (Courtesy of Gulfport Rotary Club.)

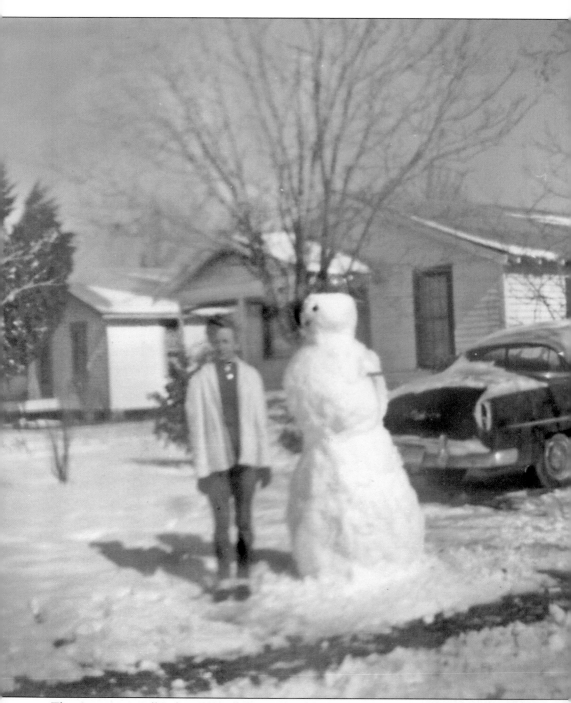

The snowman is taller than Mayzell Hancock, who is 4 feet, 11 inches tall here. The snowfall in the winter of 1963 was so unusual that the schools closed and many traffic accidents resulted, as many people were driving without any experience with snowy road conditions. (Courtesy of Mayzell Hancock.)

The Handsboro community to the east of Gulfport played an important role in lumber exports. Handsboro was north of Mississippi City on the Bernard Bayou. Handsboro was also annexed by Gulfport. This shows fishing from the Bayou Bernard Bridge. (Courtesy of Paul Jermyn.)

The Gulf Coast Military Academy was a premier prep school for young men. The prestigious school was located on East Beach Boulevard. Started in the 1920s, the young men were generally from wealthy families who wanted to provide them with a superior education. Many students came from the New Orleans area. When the school closed, the facility was taken over by William Carey College. (Courtesy of Paul Jermyn.)

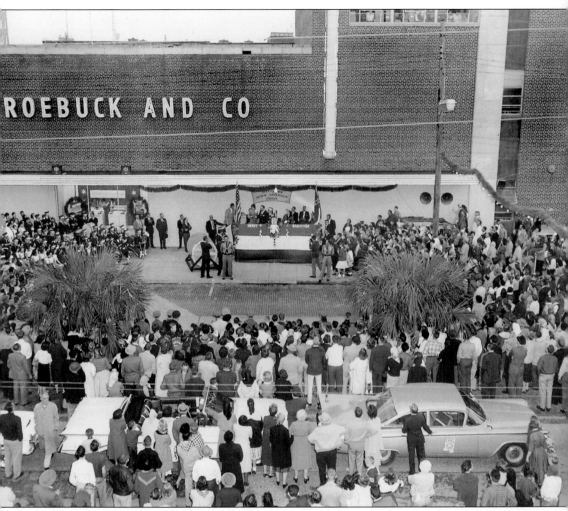

When Sears, Roebuck, and Co. opened in downtown Gulfport, there was a big celebration. The two-story building was designed by the firm of H.D. Shaw and Associates. It was the first and only shop with an escalator in Gulfport. Sears moved to Edgewater Mall in Biloxi during the late 1960s. The building is now home to Whitney Bank on the first floor and other business offices on the second floor.

The 1963 Commodores football team of Gulfport High School were champions. According to the *Associated Press* Poll State Champions, they were Big Eight cochampions. That year, the team won 10, lost zero, and tied once. (Courtesy of Allan Jones.)

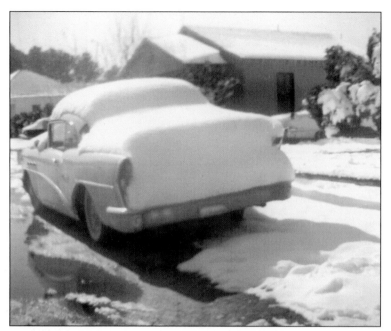

The snow that fell during the winter of 1963 caused a major inconvenience to drivers who had never seen it before. The bigger news was in New Orleans, Louisiana, where the 1964 Sugar Bowl championship football game was to be played on New Year's Day. The bleachers at Tulane Stadium were covered in snow, hampering the game that year. (Courtesy of Mayzell Hancock.)

This Gulfport Supply Club Christmas celebration was most likely held in the early 1970s. The back of the photograph reads: "Seventh from left is Philip W. Shaw, Sr. The Mennonites and the club had some connections that I am not sure of but many came after Camille and stayed. Mr. Shaw was probably mayor when this was taken. I am researching the Mennonite presence in Gulfport from 1969."

120

The Gulfport Woman's Club is a ladies' organization interested in community service. They are part of a national association, with a physical location in Jackson, Mississippi. The home for the Gulfport Women's Club was on East Beach Boulevard, but Hurricane Katrina destroyed the facility. To replace this location, the group purchased a house near Pass Road in Gulfport. (Courtesy of Joe Casey.)

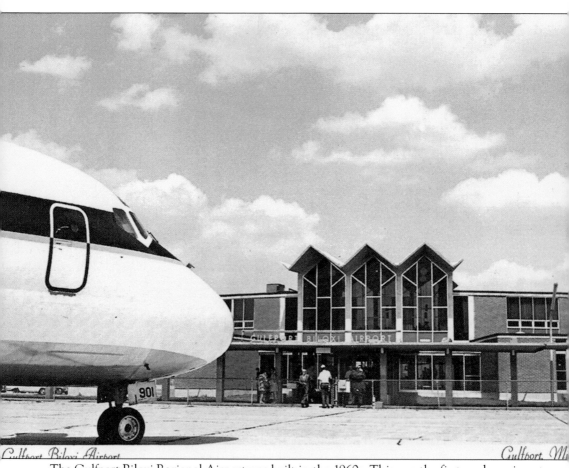

The Gulfport-Biloxi Regional Airport was built in the 1960s. This was the first modern airport terminal. It has been replaced by a multimillion-dollar facility on the same property. (Courtesy of Joe Casey.)

The Shoo Fly was a wooden structure built around the trunk of a large oak tree. Like a gazebo, it provided seating for people looking for a respite from the heat. The boughs of the oak trees, which are plentiful in Gulfport, form a canopy of shade. Shoo Flies were popular and commonly seen on lawns of homes and hotels that faced the beach in Gulfport. Sometimes the trees grew too large for the bench or a storm blew the structure down. Though uncommon, there a still a few Shoo Flies around. This one in Jones Park is long gone. Jones Park was a large area of land donated by descendants of Capt. Joseph Jones. Located south of Highway 90 and north of the small-craft harbor, it is designated as a public recreation area. (Courtesy of Joe Casey.)

Gulfport is currently home to only one casino operation. The Island View Casino is the locally owned casino on the coast. It had operated as the Copa Casino for several years as a barge facility. When Hurricane Katrina washed the Copa on to Highway 90, the owners purchased the Grand Casino's Gulfport facilities. Island View is the name of an area in West Gulfport where the casino is located.

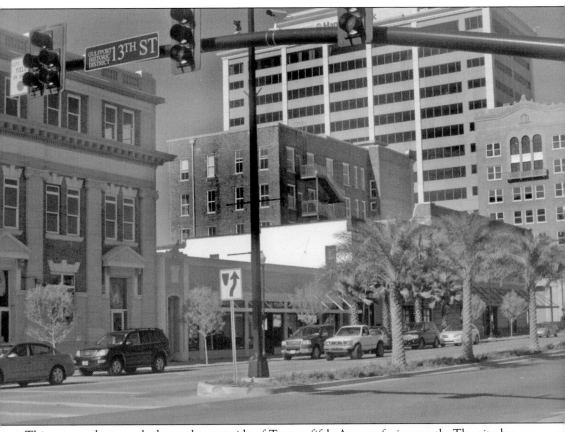

This recent photograph shows the east side of Twenty-fifth Avenue facing north. The city has recently planted palm trees in the median. This is one of only a few blocks of downtown Gulfport with buildings still intact. The three-story Kremer building has a restaurant located on the first floor. The Hancock Bank, with both its old and new buildings, is visible in the background.

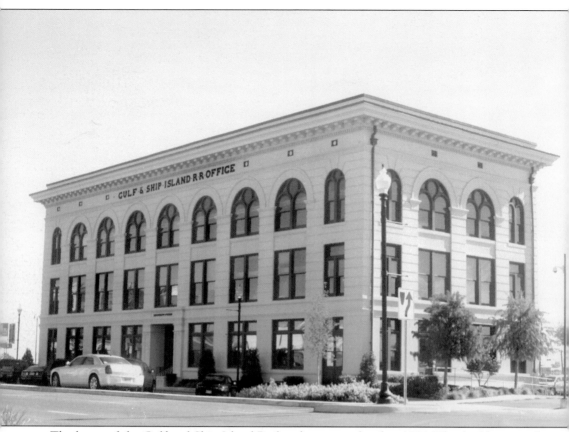

The home of the Gulf and Ship Island Railroad was completed in 1906. This building stands as a tribute to Capt. Joseph T. Jones, who dreamed of a thriving and vibrant city. The building, renovated by Mississippi Power Company over 25 years ago, is a beautiful reminder of the past.

There is welcome sign standing at the city limit between Long Beach and Gulfport. The monument sign, surrounded by palms, is new. The beautiful view of the Mississippi Sound and the still-thriving Port of Gulfport are untouched.

DISCOVER THOUSANDS OF LOCAL HISTORY BOOKS FEATURING MILLIONS OF VINTAGE IMAGES

Arcadia Publishing, the leading local history publisher in the United States, is committed to making history accessible and meaningful through publishing books that celebrate and preserve the heritage of America's people and places.

Find more books like this at
www.arcadiapublishing.com

Search for your hometown history, your old stomping grounds, and even your favorite sports team.